The Pursuit of Capyness
A Zen Capybara Coloring Book

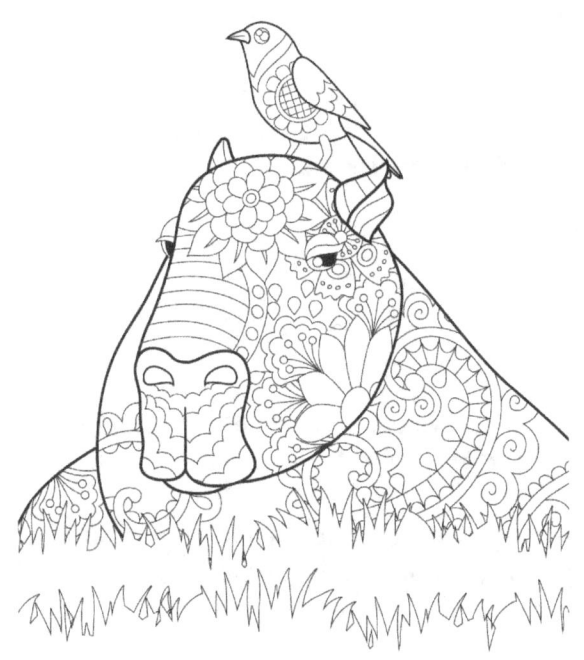

Dr. Jonathan Terry

Dr. Jonathan Terry
Clovis, CA
United States
2019

The Pursuit of Capyness: A Zen Capybara Coloring Book

Copyright © 2019 by Dr. Jonathan Terry

All rights reserved. No part of this book may be reproduced or transmitted in
any form or by any means without written permission.

ISBN: 978-1-69715-170-1

Names, characters, events, and incidents are the products of the editor's imagination;
any resemblance to actual images, persons, animals, or actual events is purely coincidental.

Proceeds from the sales of this coloring book may be used to fund mental health initiatives
at the discretion of the editor. For more information, please visit www.mycapybara.com.

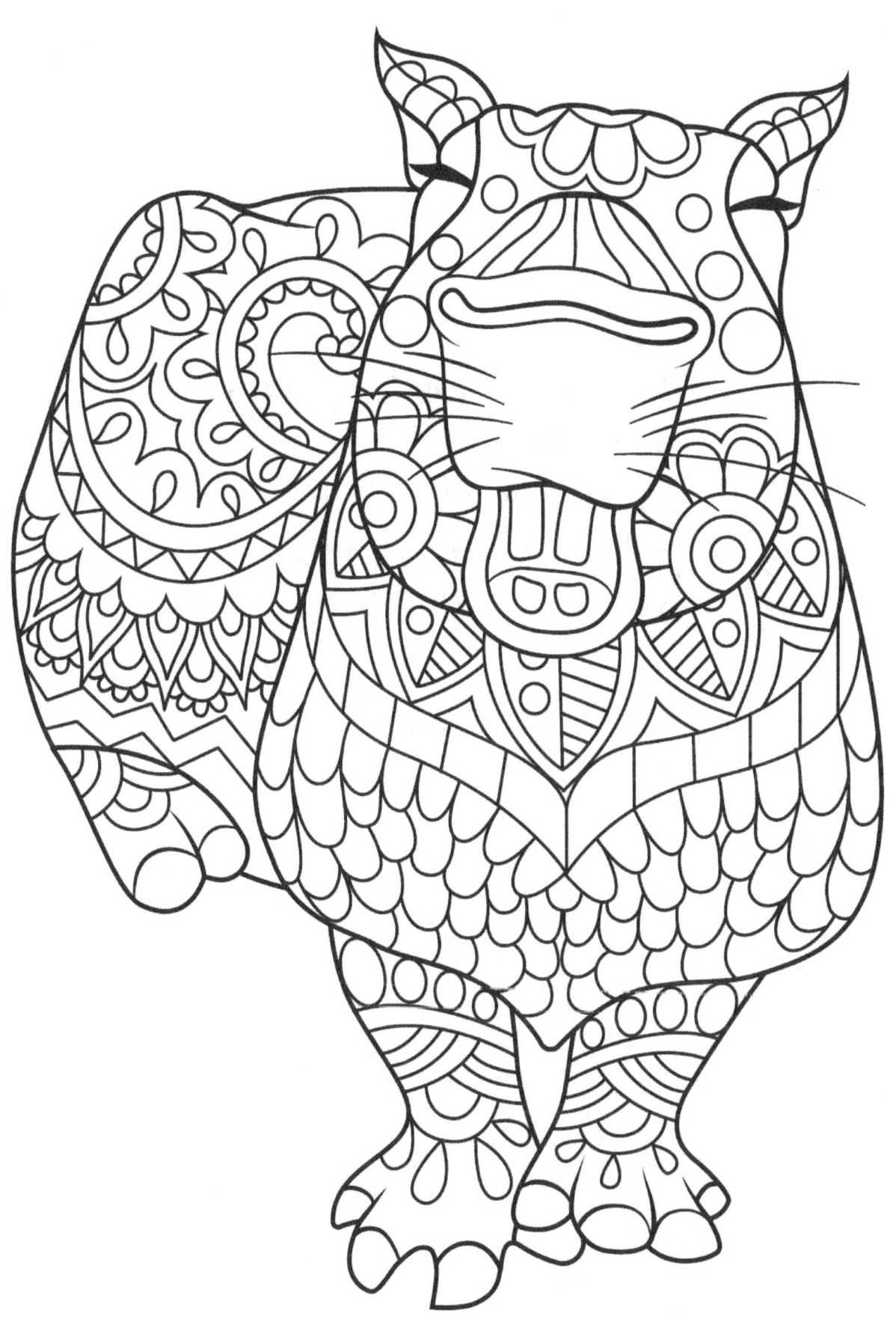

The capybara is the largest rodent on Earth. Adults grow to about 120cm (~4ft) and weigh about 50kg (~110) pounds.

That's a big rodent!

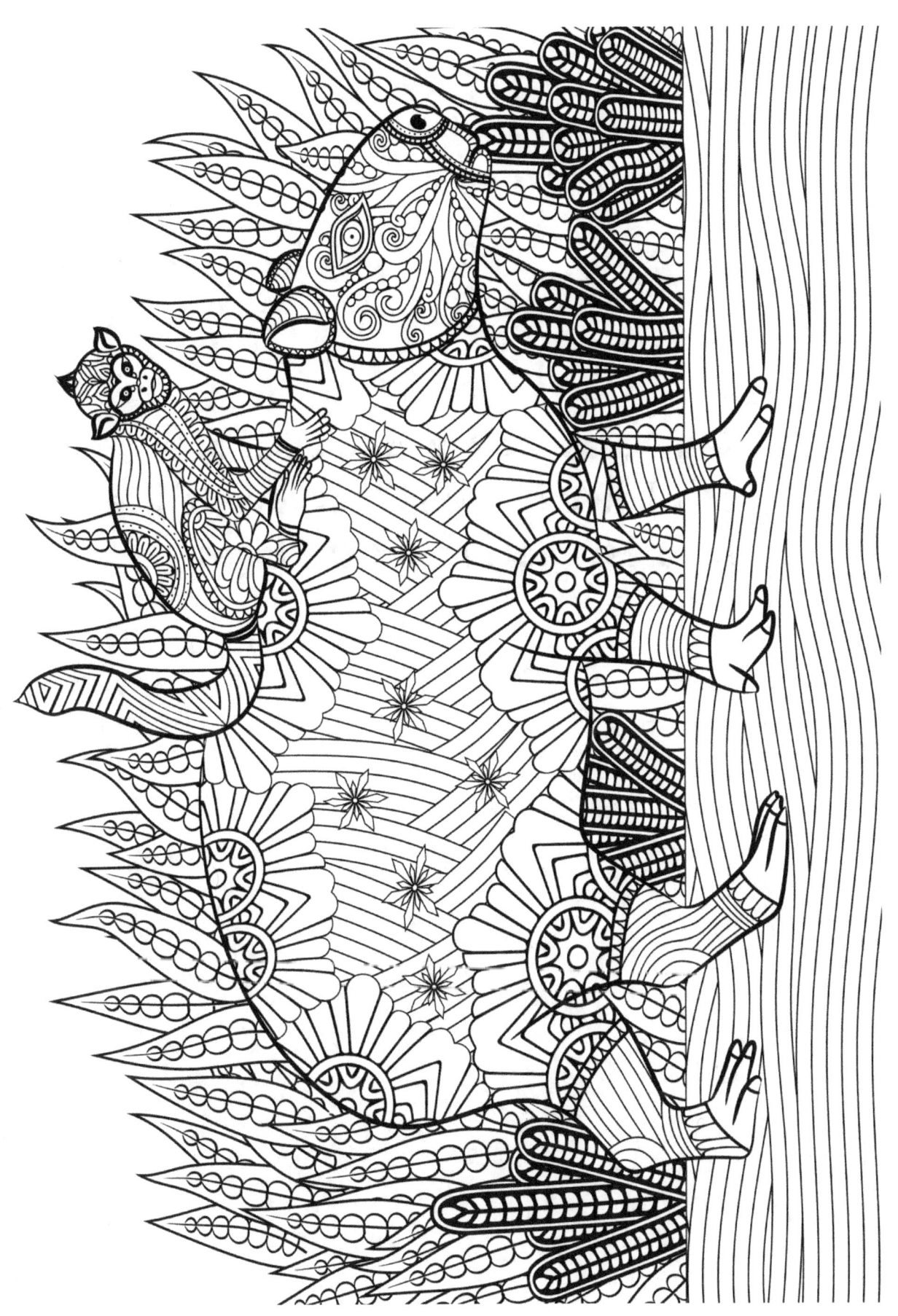

Capybaras are found in most of South America, and they love to live in forests near rivers and lakes.

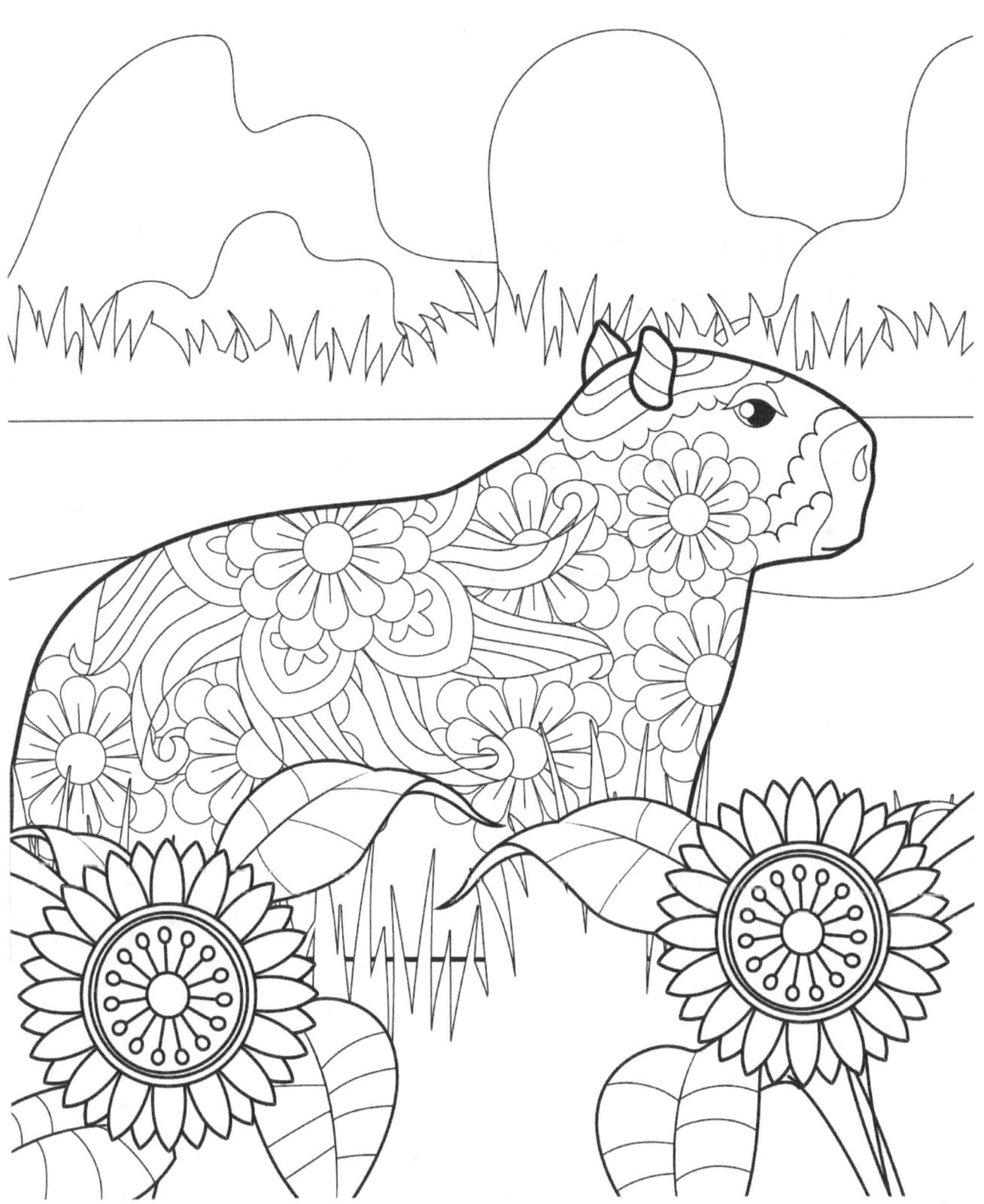

Capybaras are excellent swimmers and spend most of their time in the water.

Some people confuse them for small hippos due to their tiny, oval ears and nostrils above the water.

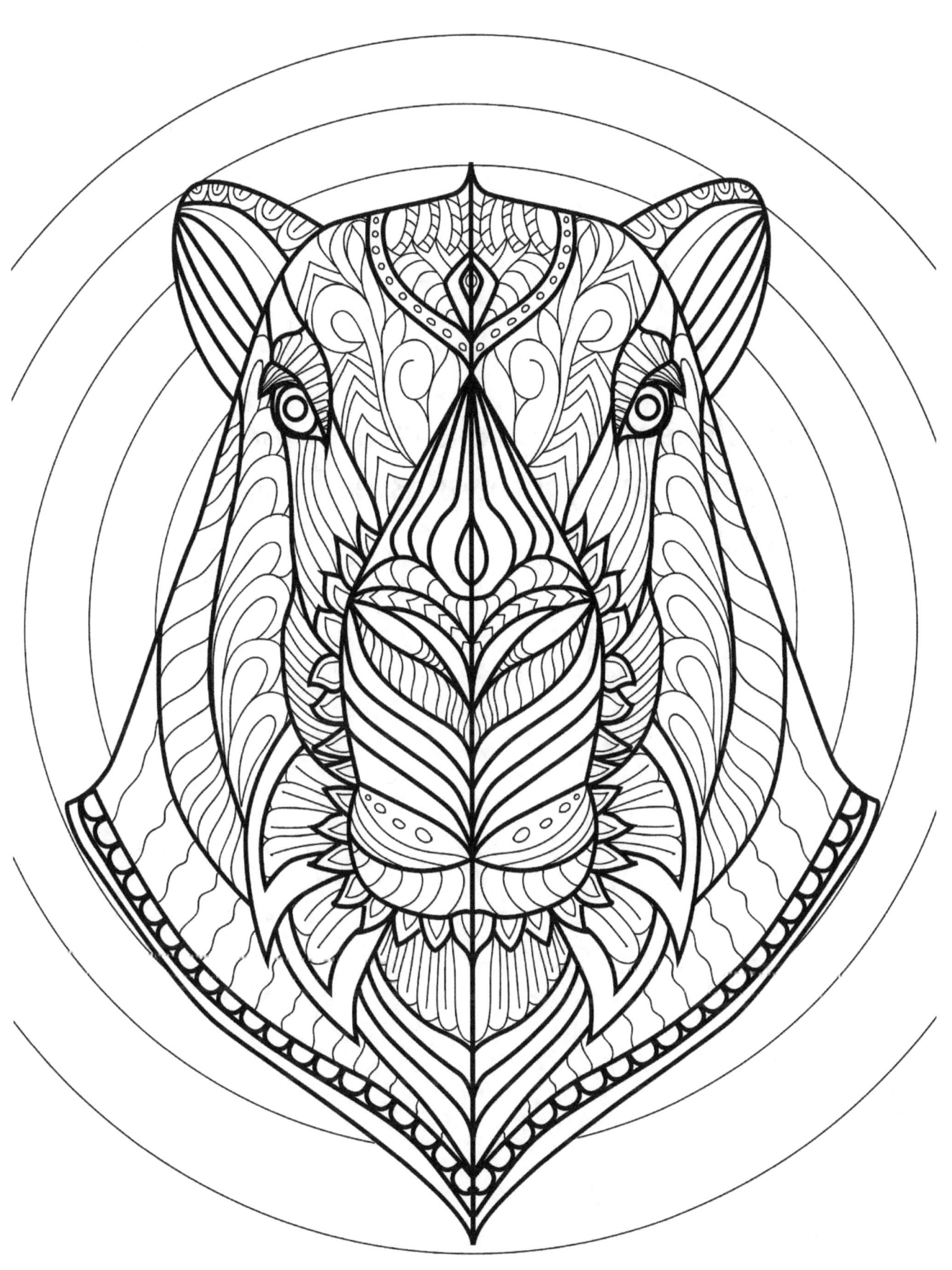

The closest living relatives to the capybara are guinea pigs and rock cavies.

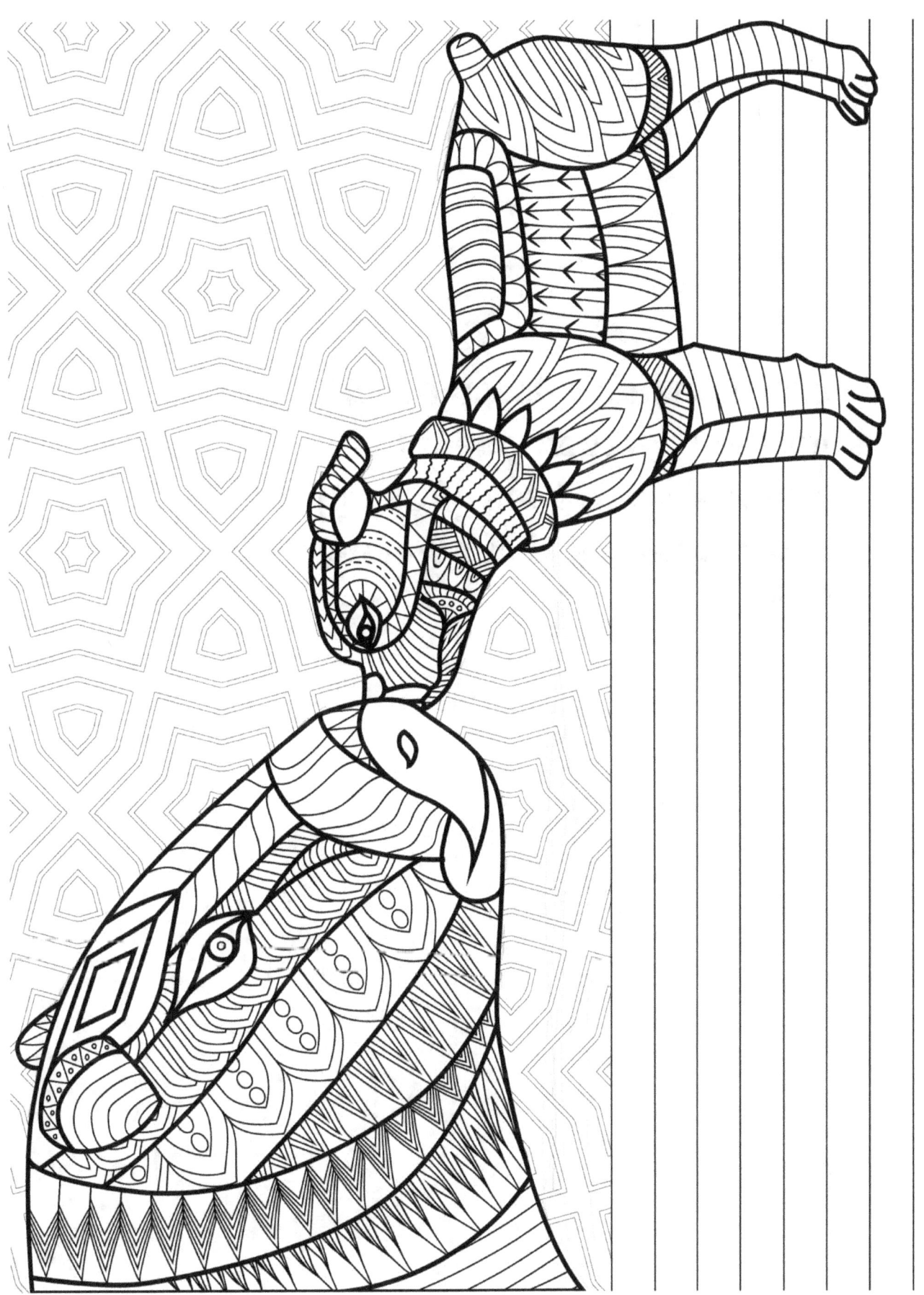

2 to 4 million years ago, Earth was home to a larger rodent that weighed up to 1 ton (908 kg) and had a length of about 3 meters (10 feet).

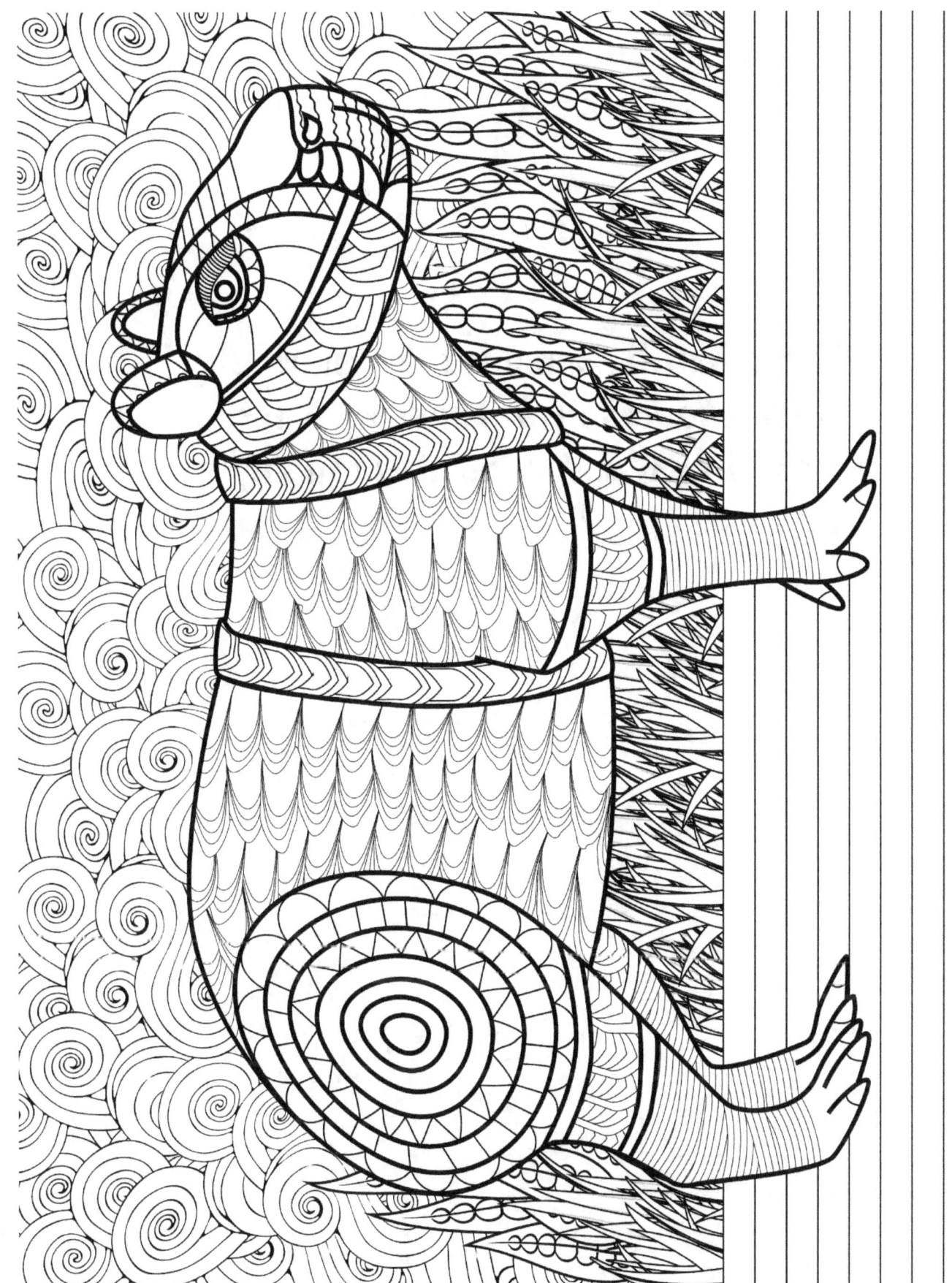

The scientific name for the capybara, *Hydrochoerus hydrochaeris*, comes from Greek, and translates roughly to "water pig."

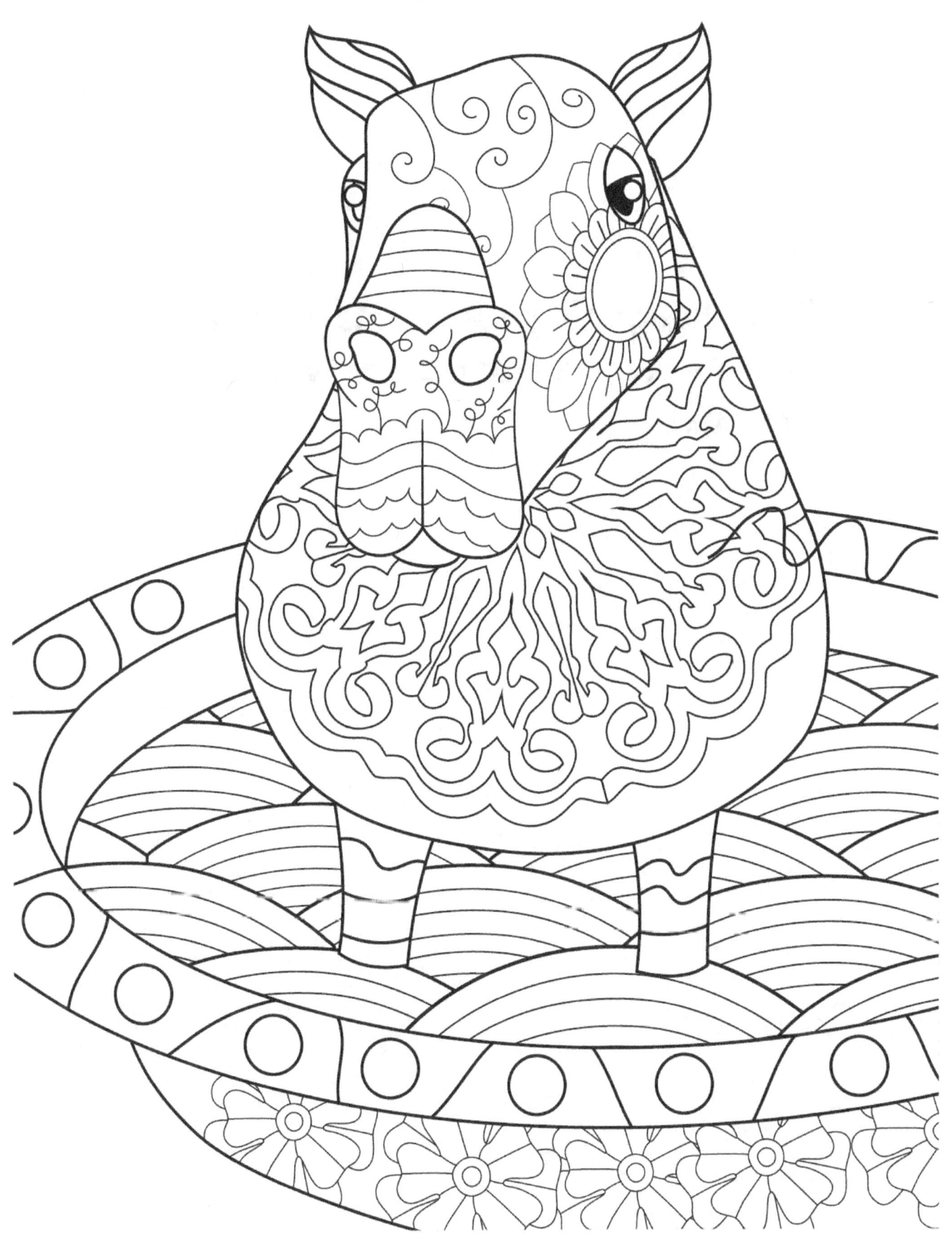

Even though they spend lots of time in the water, capybaras have very dry skin!

Feet are designed for swimming, with slight webbing. The capybara can also press the ears against the head to keep water out.

Some capybaras can stay under water for 5 minutes! This helps them avoid predators like jaguars, eagles, caimans, anacondas, and yes, even humans.

Grasses and water plants are the favorite foods for the capybara.

Sometimes they also eat their own poop (to get more nutrients from the original meal). Like large land mammals, sometimes they regurgitate (throw up) their food to eat it again.

It's a good thing they are cute!

Some of us find capybara puns capy-tivating!

They help us not to worry and instead just be capy.

What's your favorite capybara pun?

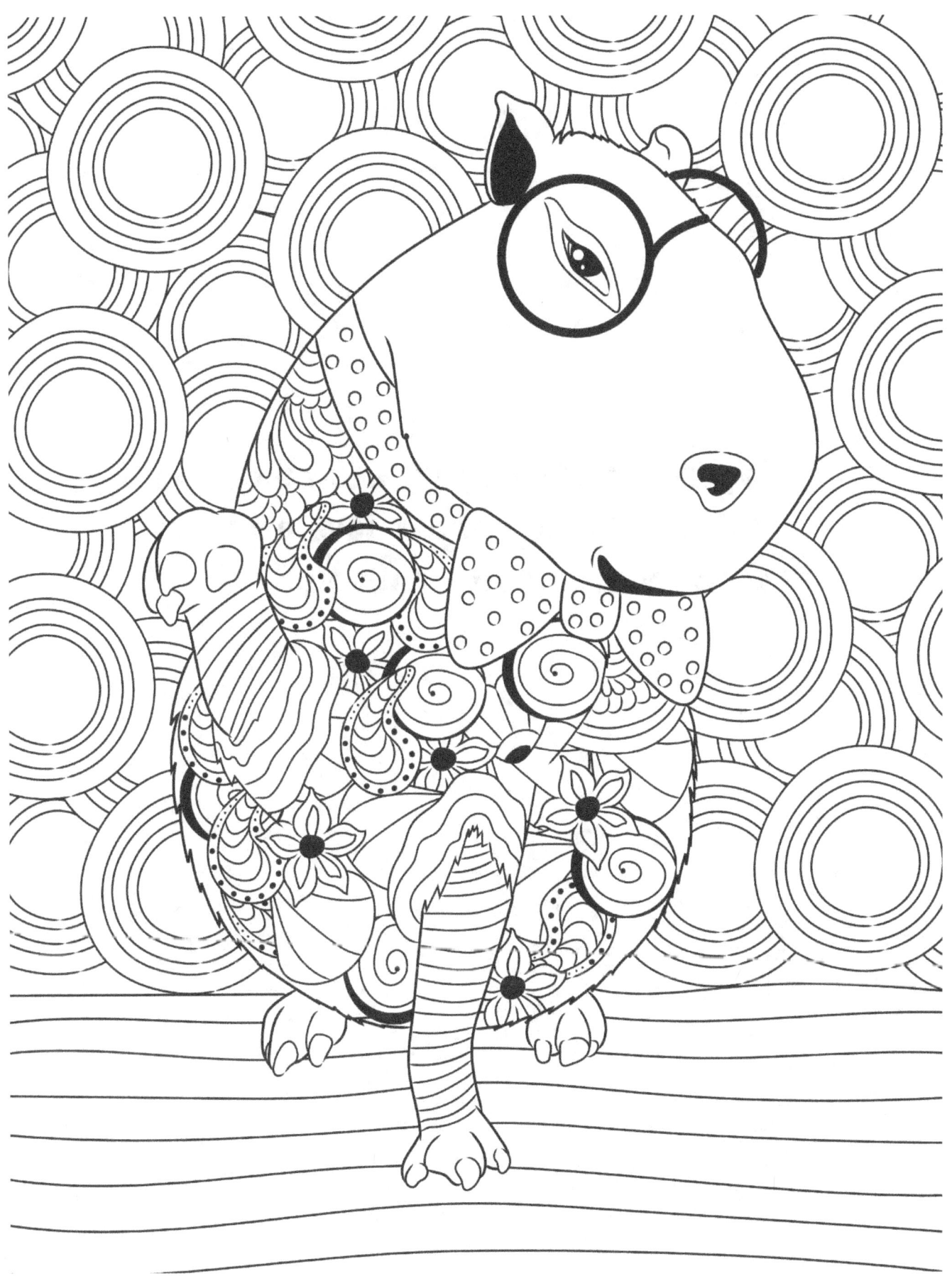

Capybaras are very smart and can be trained. Some people have even used them as guide animals!

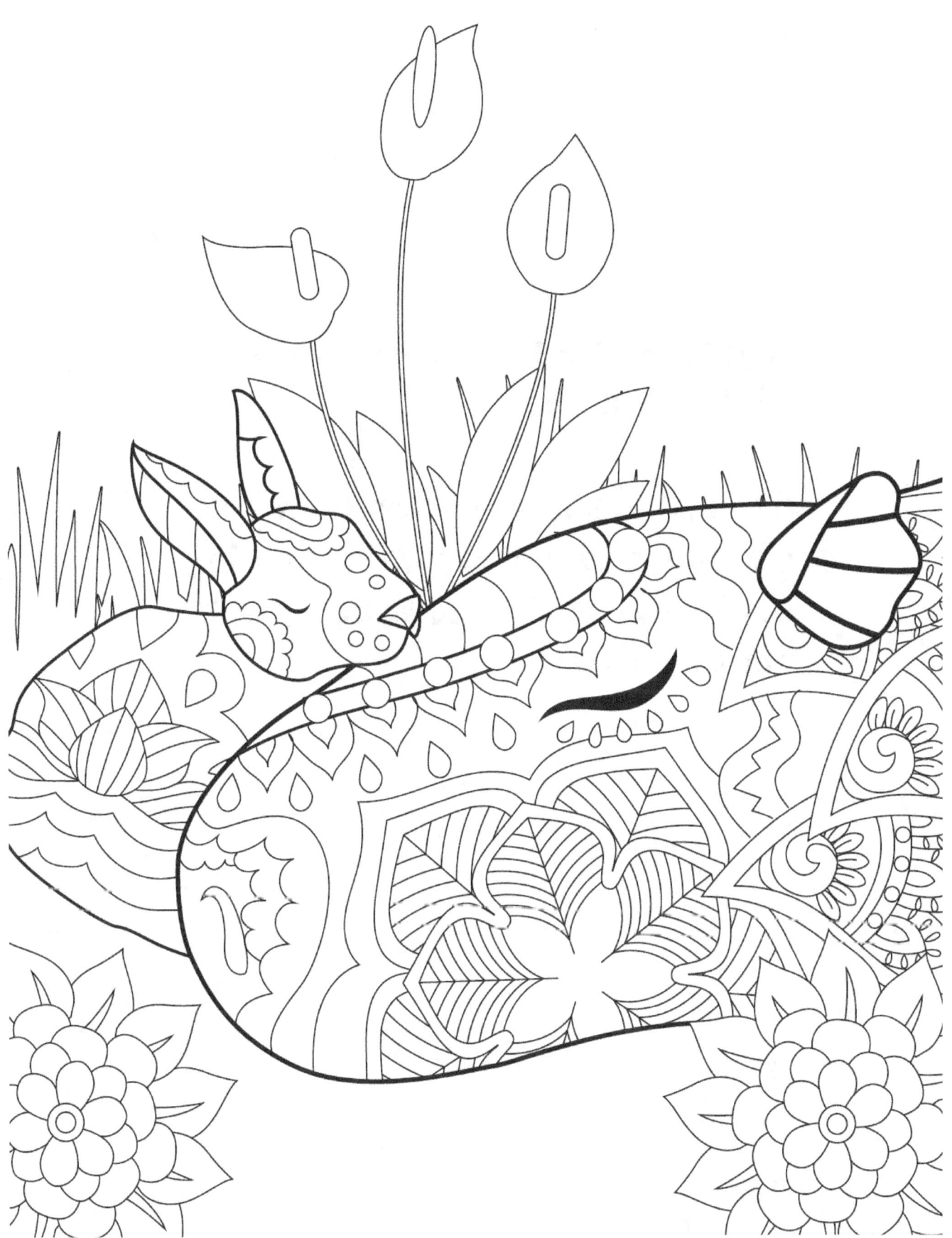

Capybaras are sometimes spotted with crocodiles.

Unfortunately, we couldn't get any crocodiles to model for the coloring book with our limited budget, so this parrot will have to do!

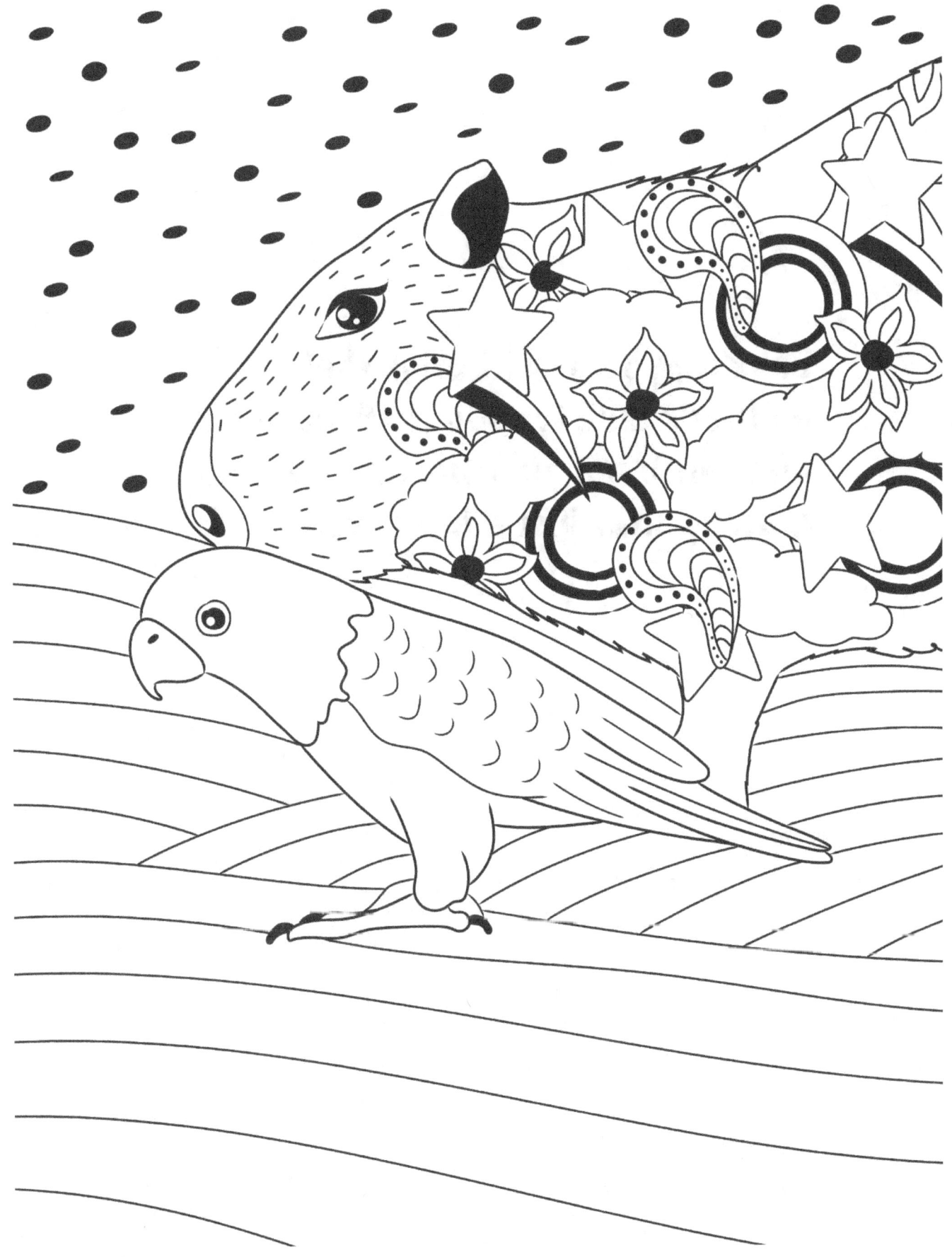

Baby capybaras will drink their mother's milk for about 16 weeks after birth but also start to graze on grasses after just a few days.

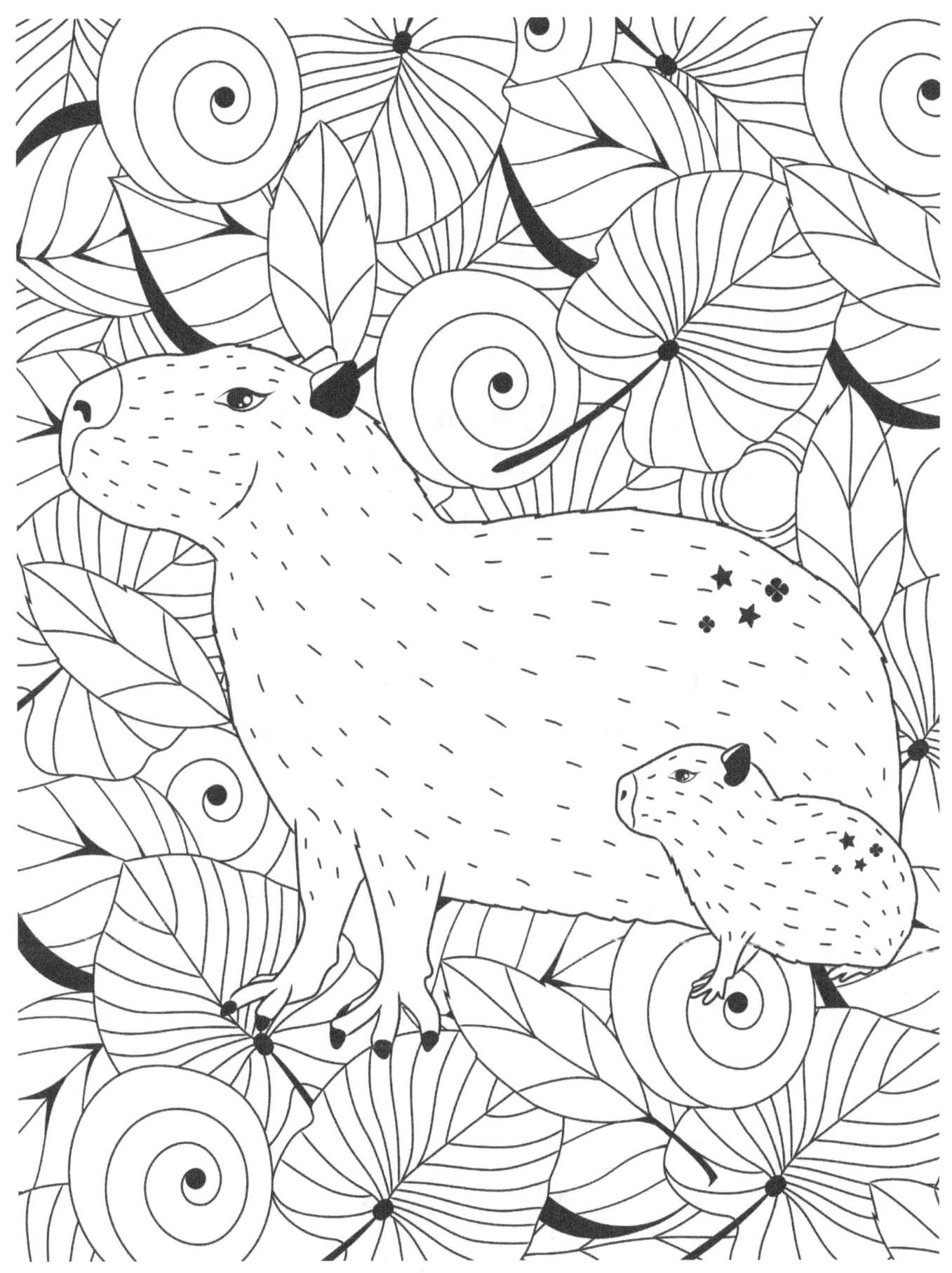

In the 16th century, the Catholic Church classified the capybara as a fish (because of its time in the water).

Do you suppose 16th-century capybaras spoke a different language than modern capybaras?

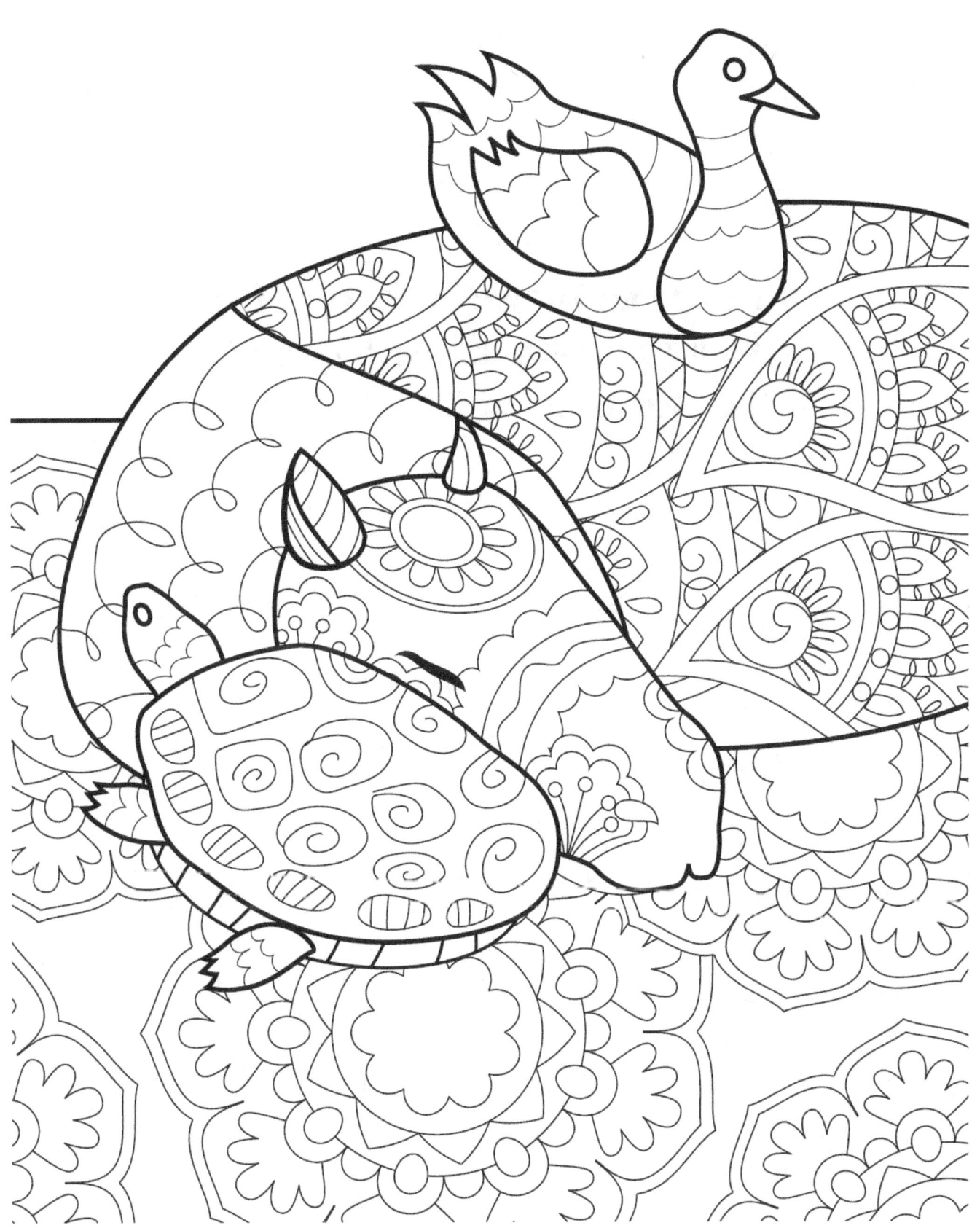

There are no known instances of the capybara training radioactive turtles in the way of the ninja.

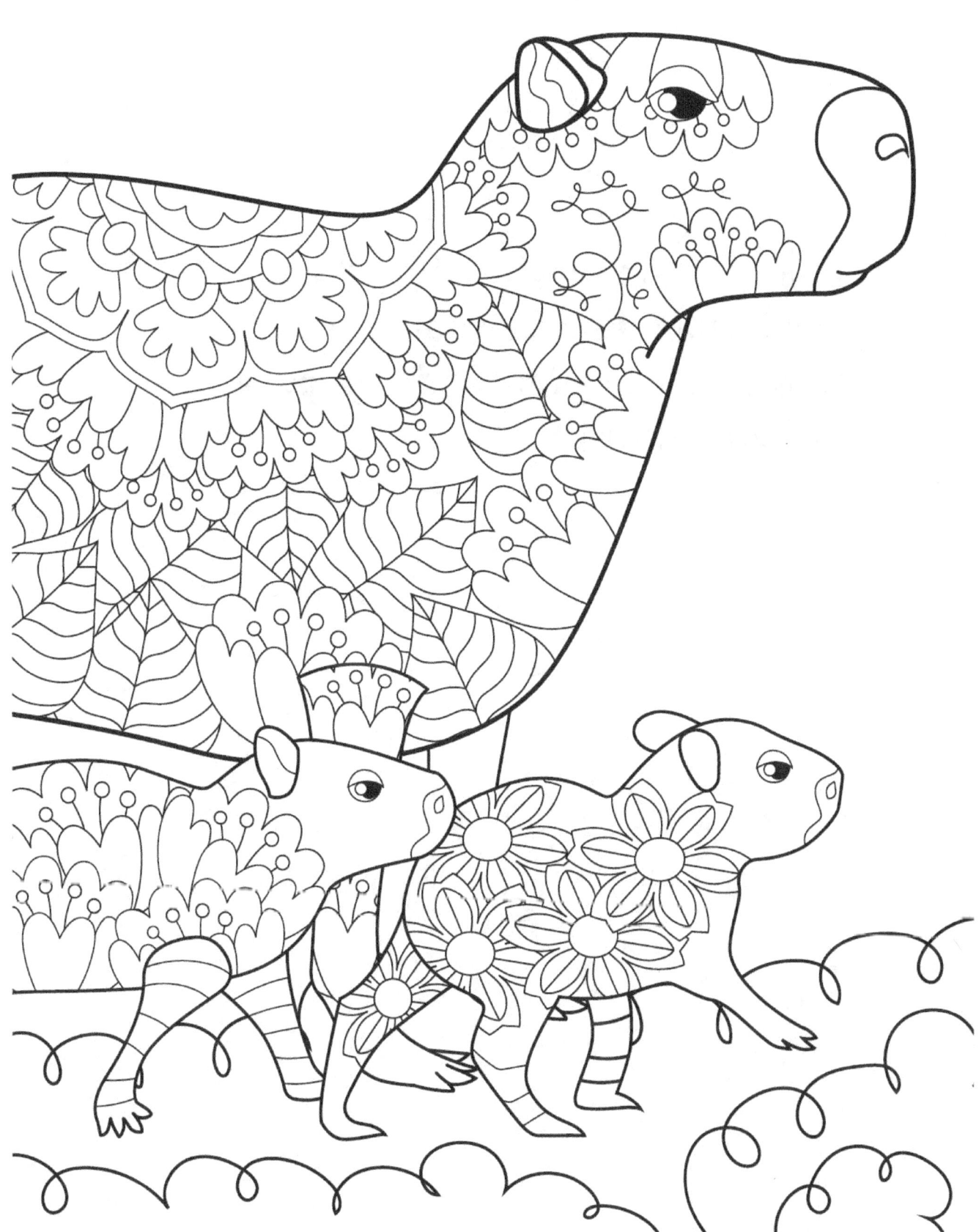

Humans farm capybaras for their meat and hide. Capybara leather is considered very fine and is popular in South America.

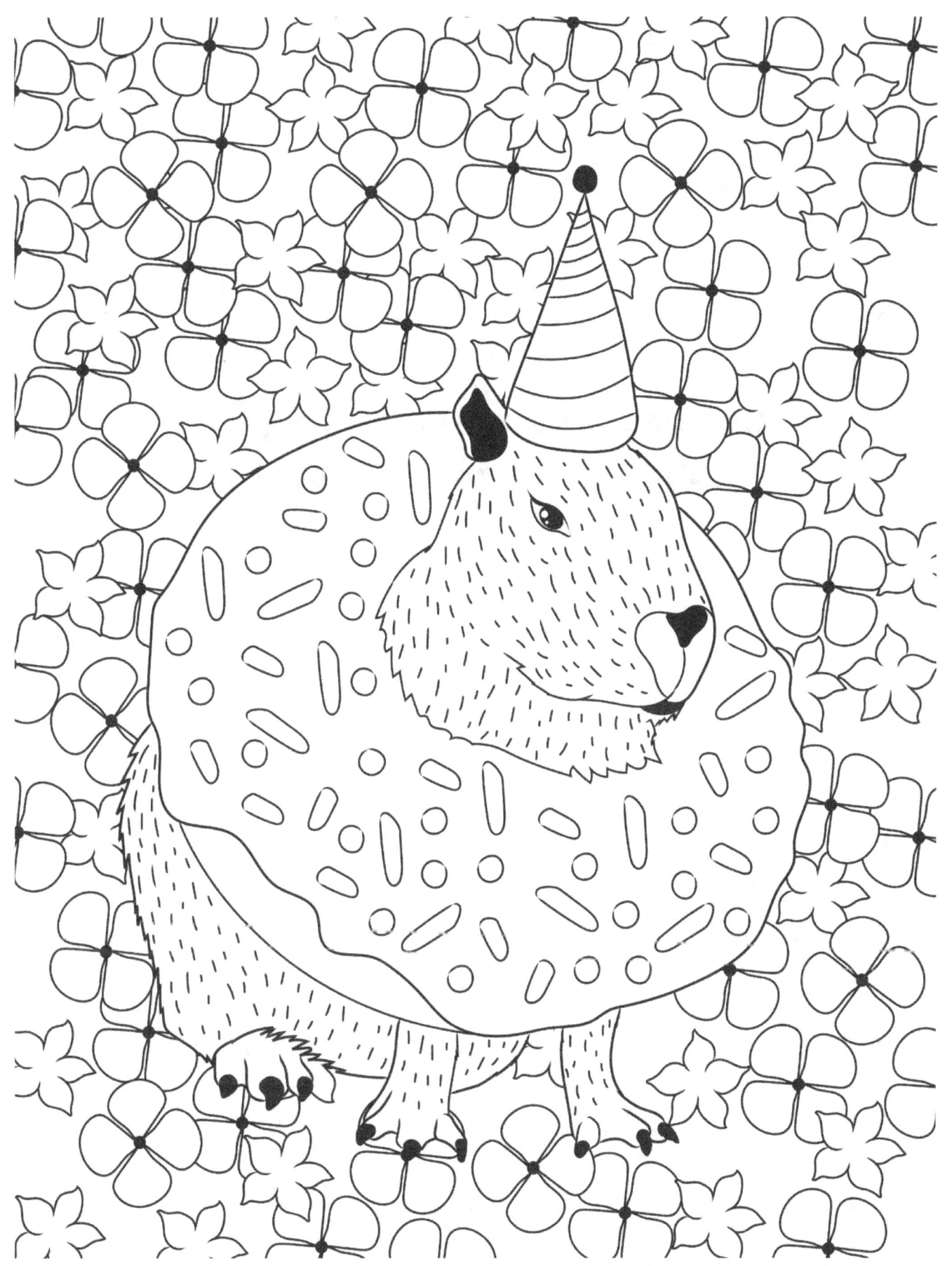

Capybaras are very social. They normally live in groups of about 10.

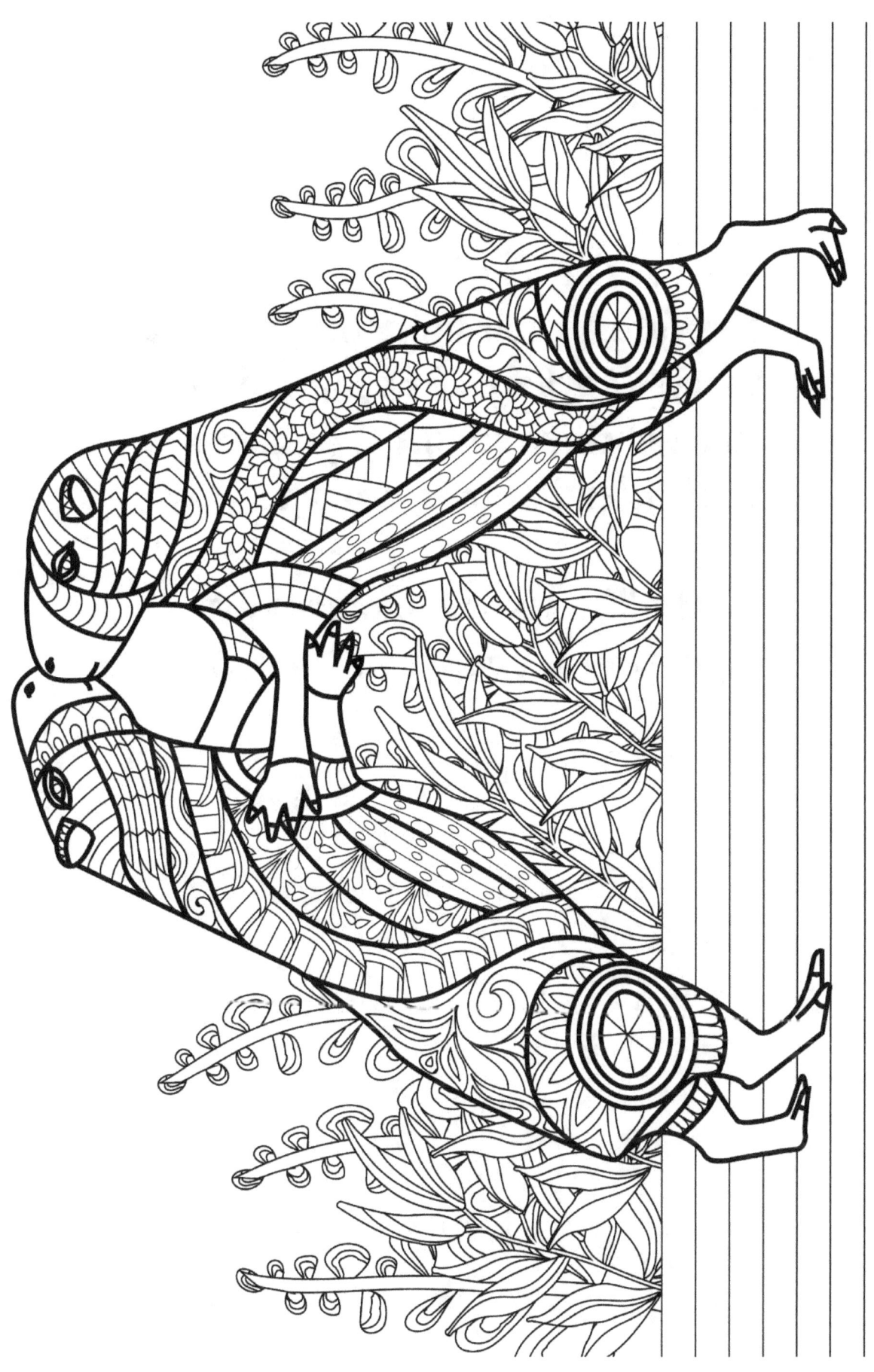

The cutest chair in nature might just be the capybara! They are often spotted carrying birds, primates, turtles, and other capybara.

We do **NOT** recommend using a capybara for your chair, though.

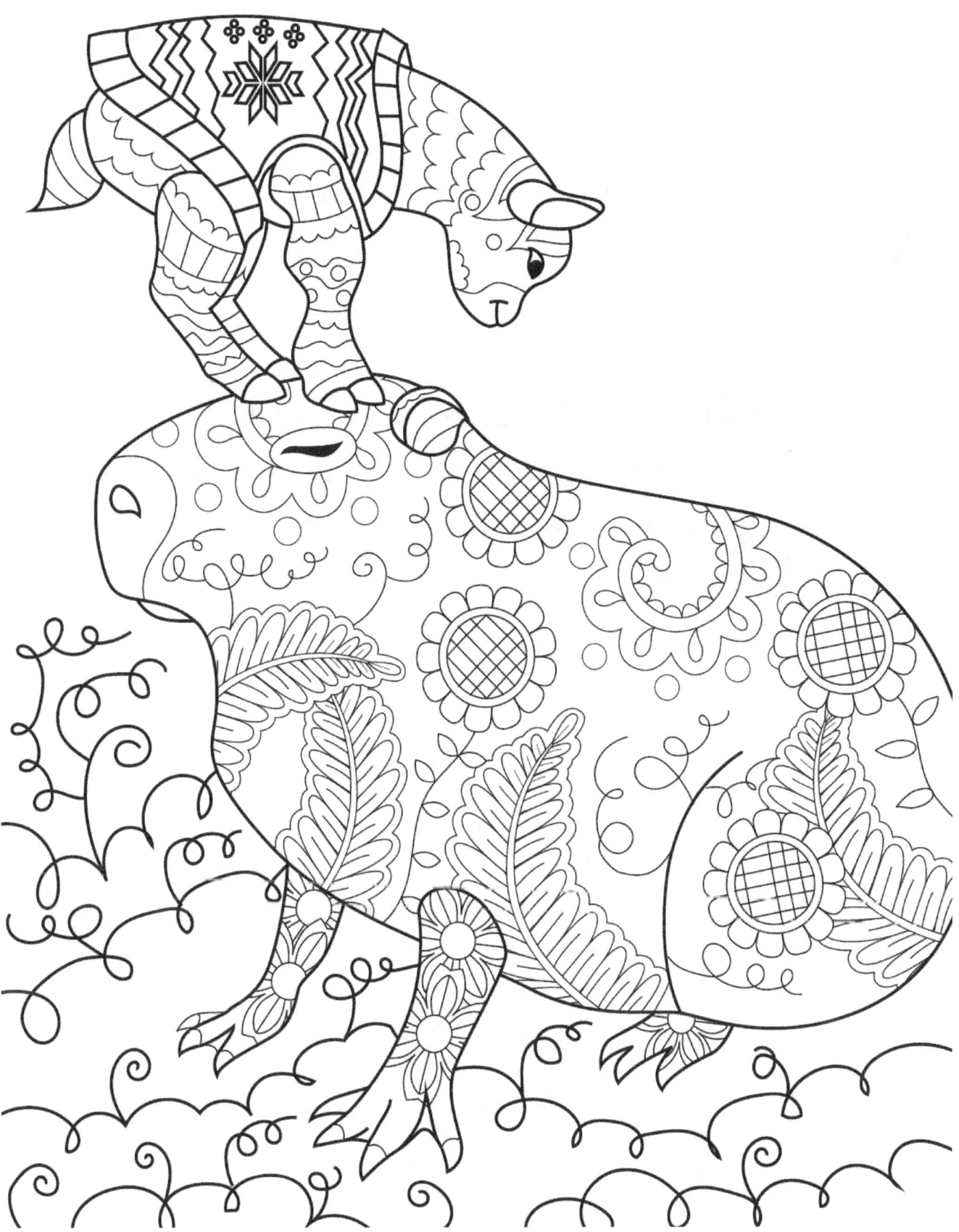

Capybara teeth can be razor-sharp! They chew side-to-side, which helps to grind up grasses for easier digestion.

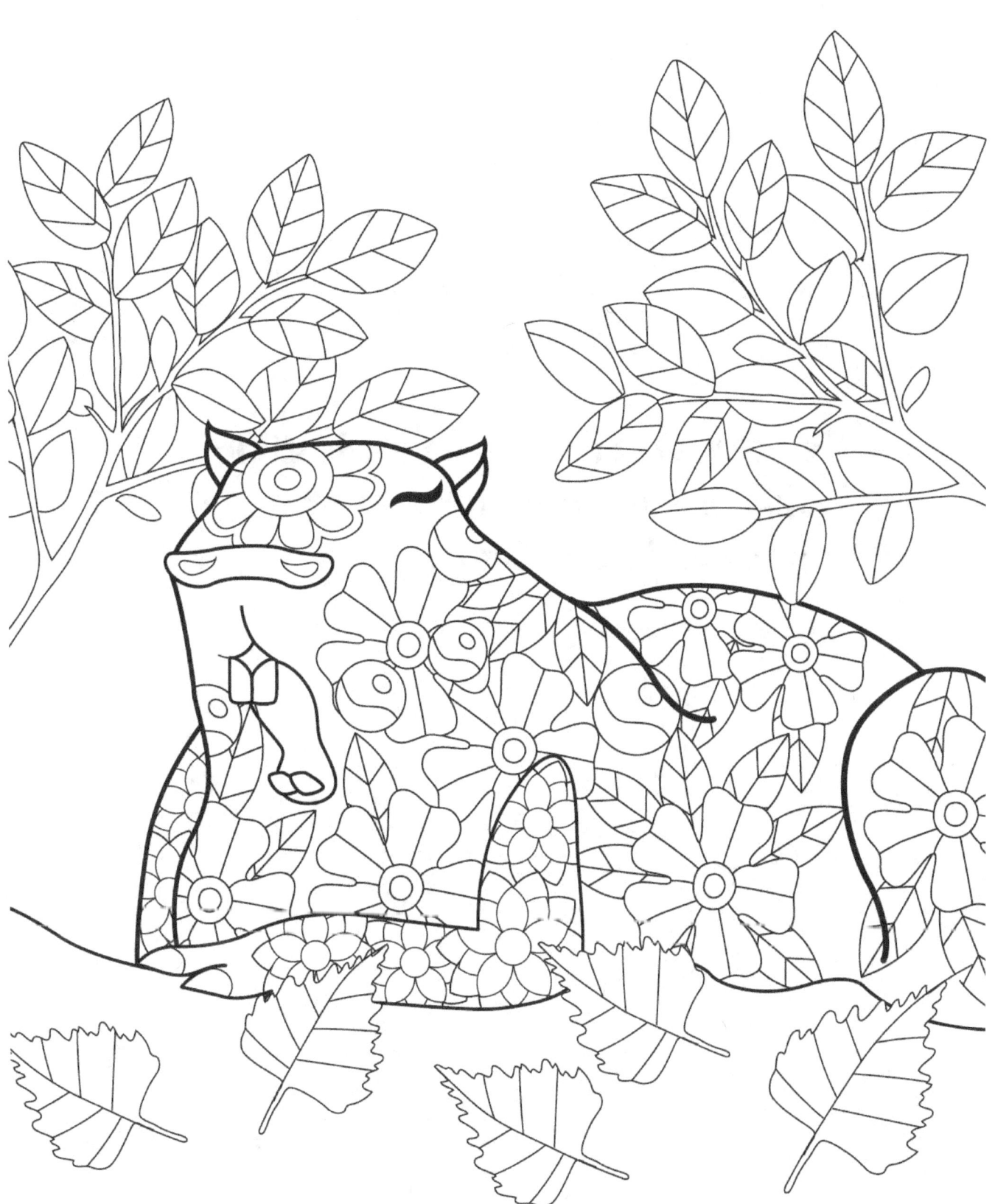

Female capybaras make a whistling noise through their nose to attract nearby male capybaras.

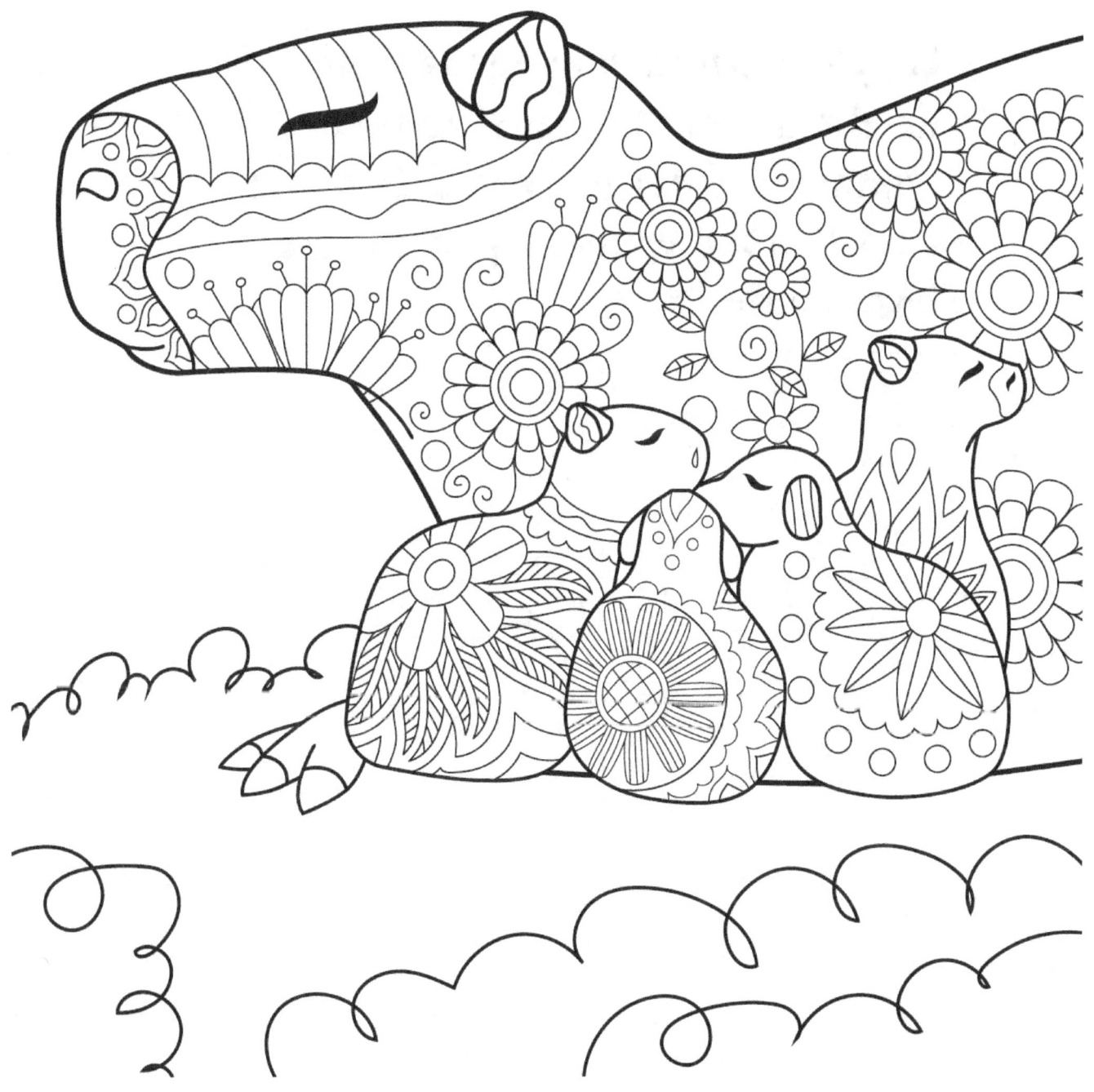

Capybara litters may range from 1-8 newborns, but the most common number is 4 per litter. While mating occurs in the water, capybaras are born on the land.

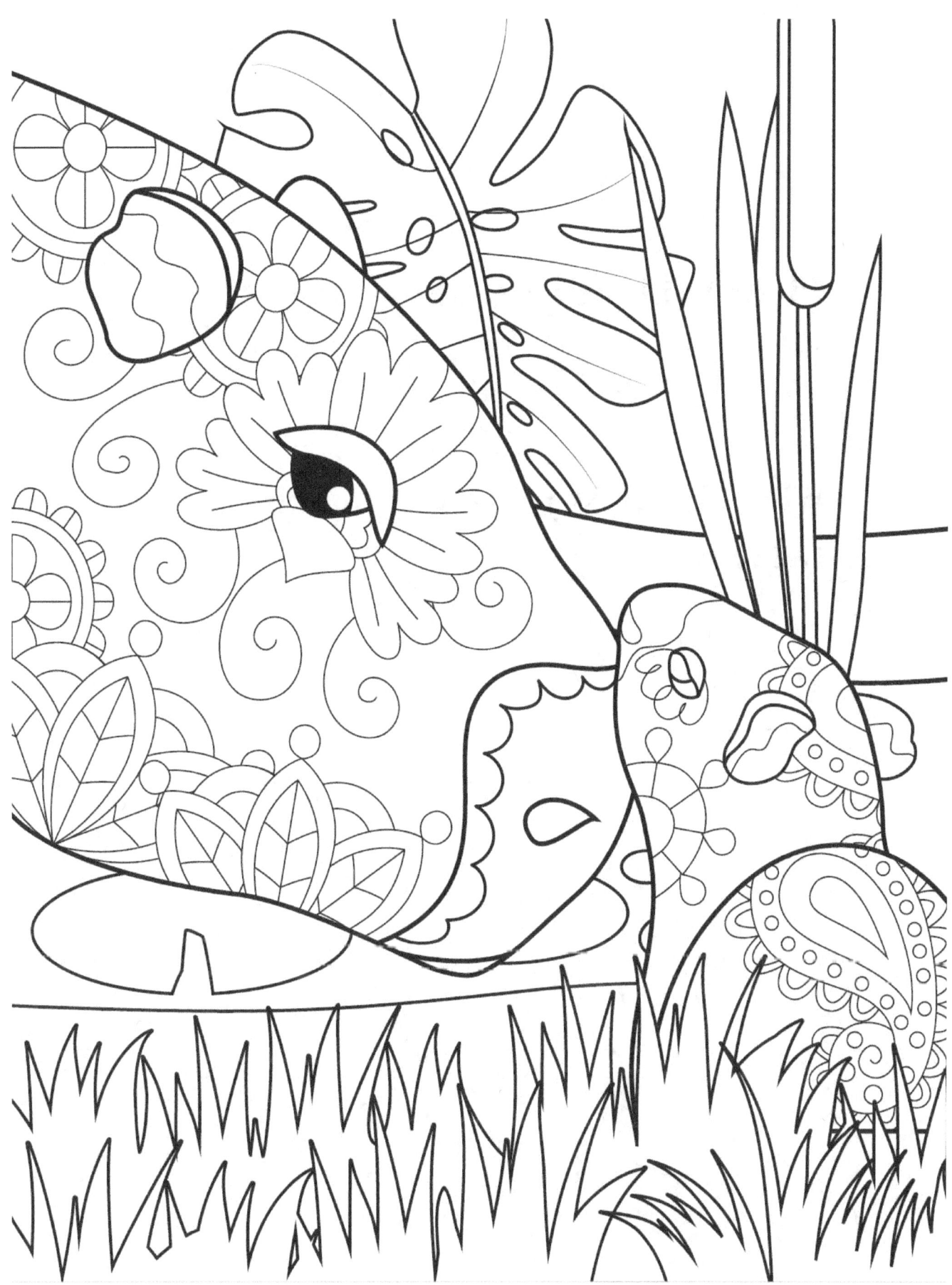

Oh my! This capybara has a cape and a mask.

What do you suppose her superhero name is?

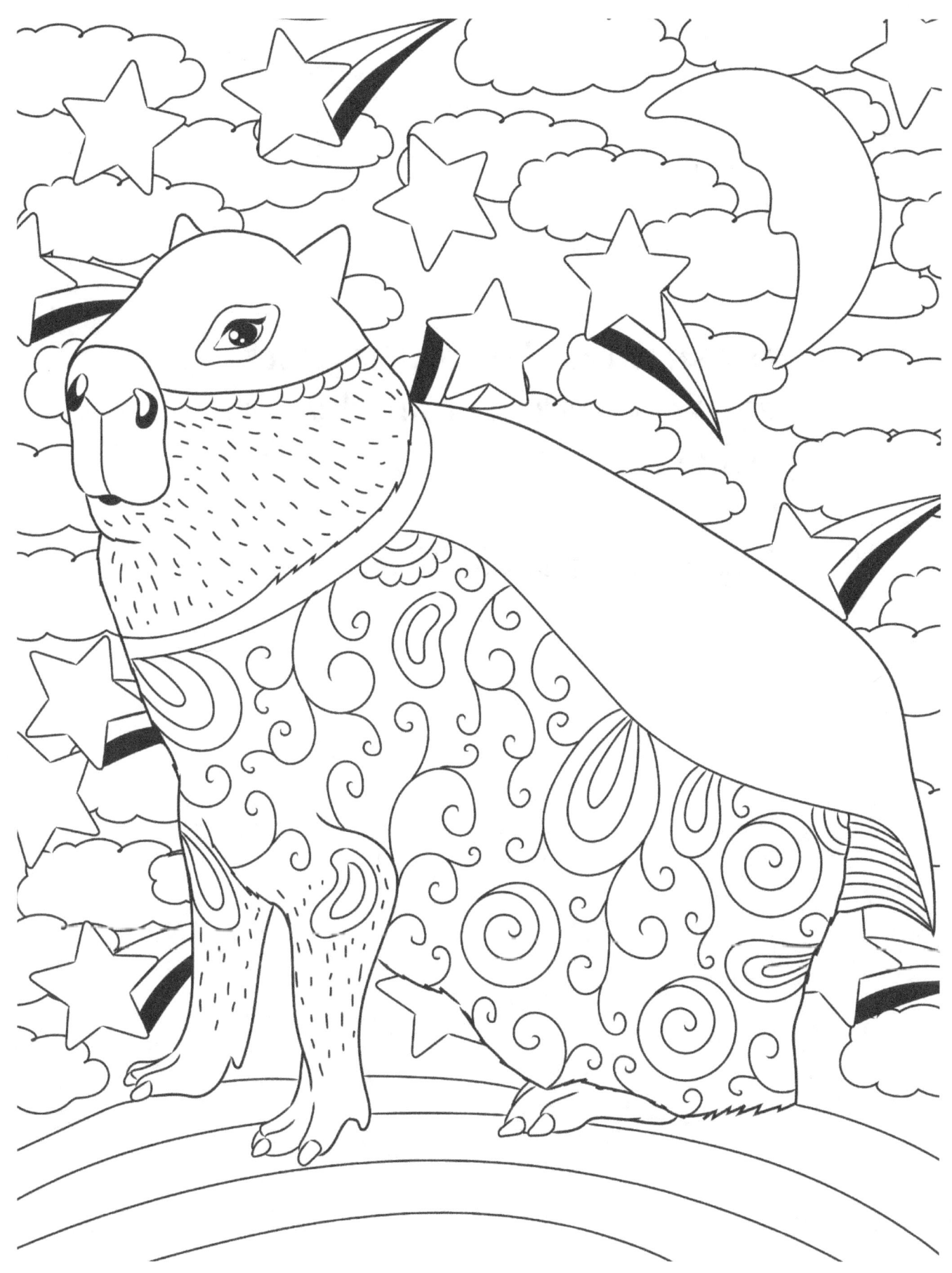

Capybaras can sleep in the water, keeping only their noses above the surface.

They are sneaky like that.

Capybara population is considered stable, and they are not endangered, though hunting has reduced their overall population.

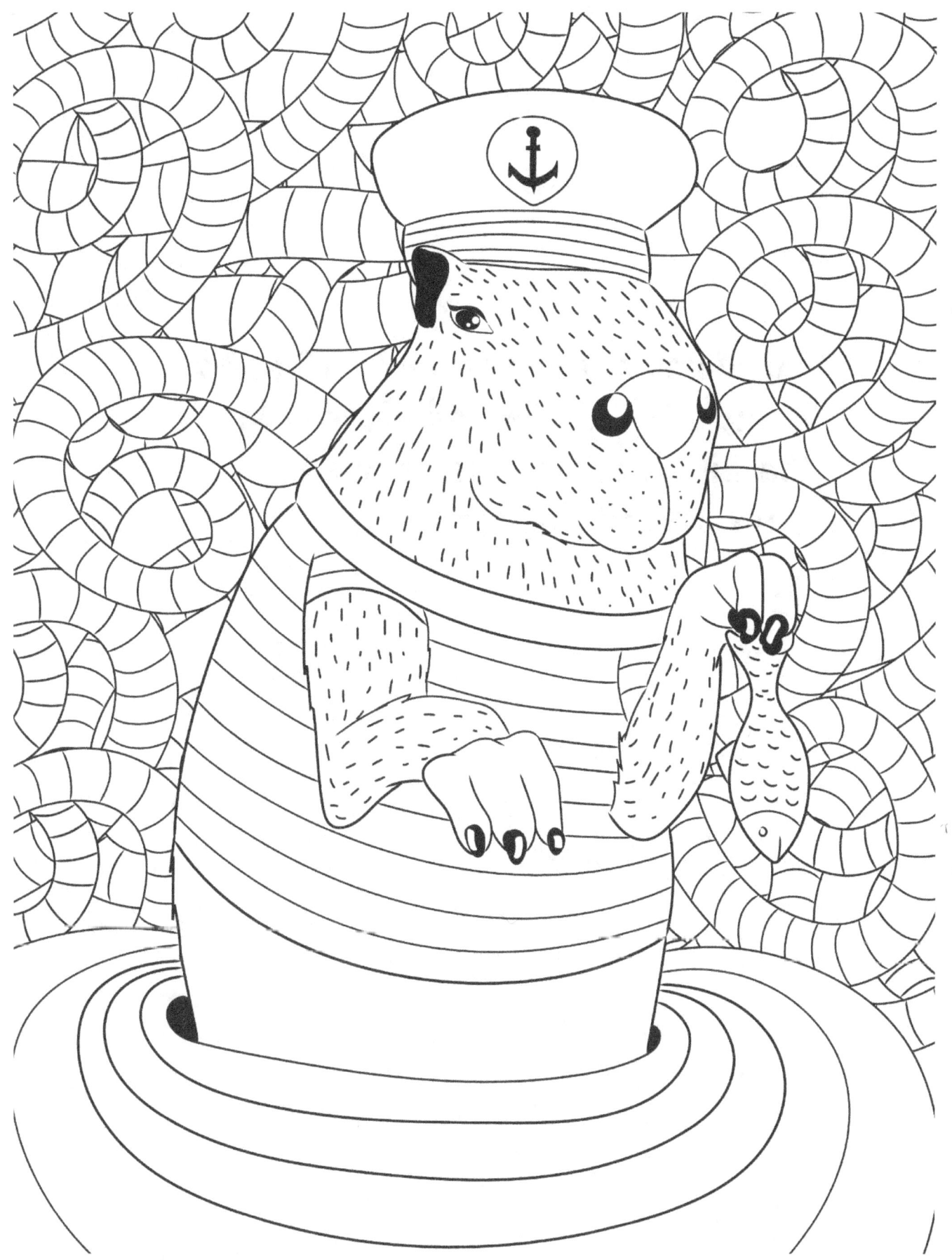

Capybaras can live for up to 12 years in captivity. Estimated lifespan in the wild is about 4 years due to many natural predators.

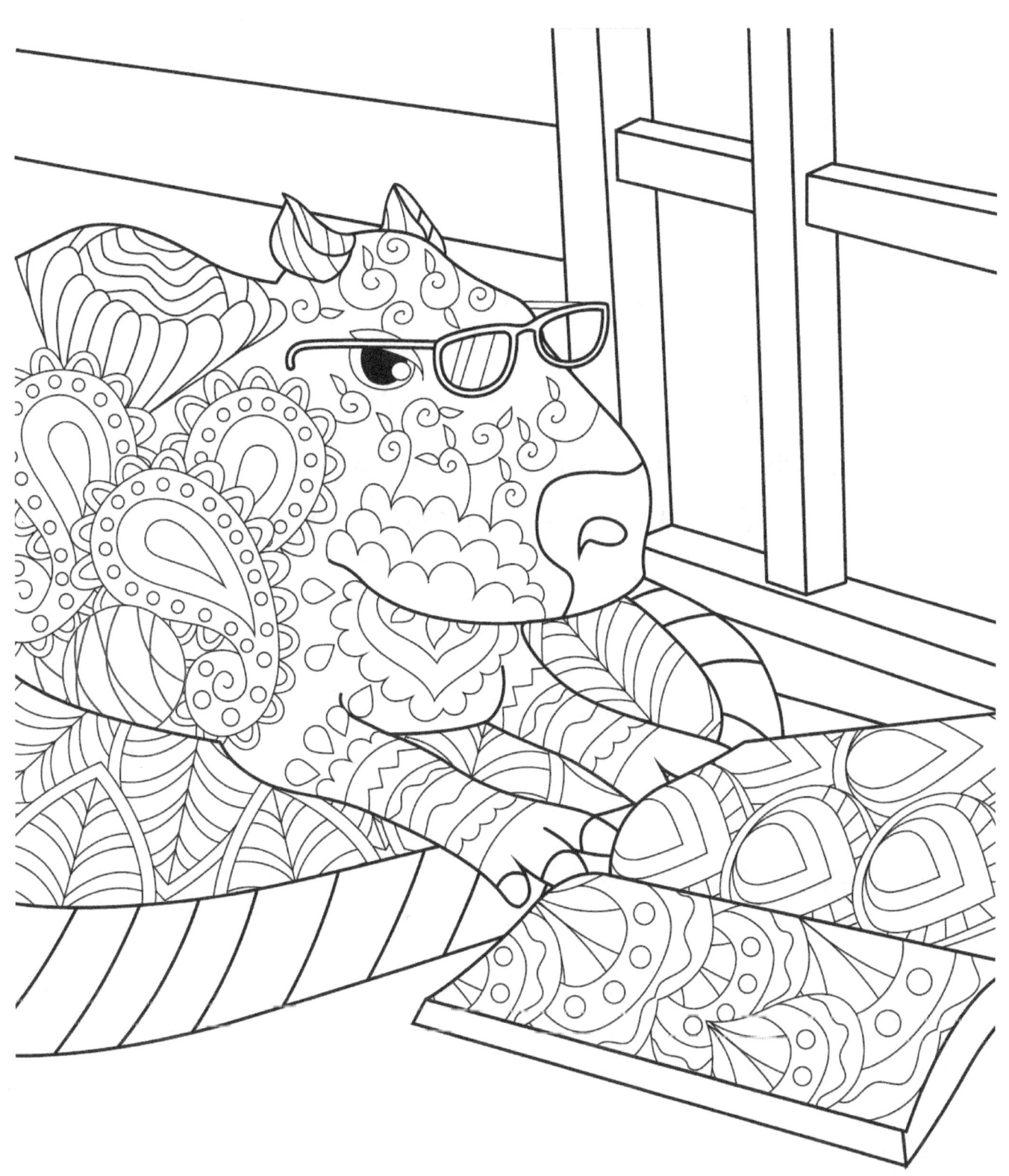

The record weight for a female capybara spotted in Brazil is 91 kg (201 lbs).

As rodents, capybaras are even more unusual because they have sweat glands in their fur.

This adds to their mystique and allure!

In addition to grasses and aquatic plants, capybaras enjoy eating farm-grown crops.

This doesn't make them too popular with farmers!

Capybaras are found in the wild almost everywhere in South America except for Chile.

CAPY CAPY

 JOY JOY !

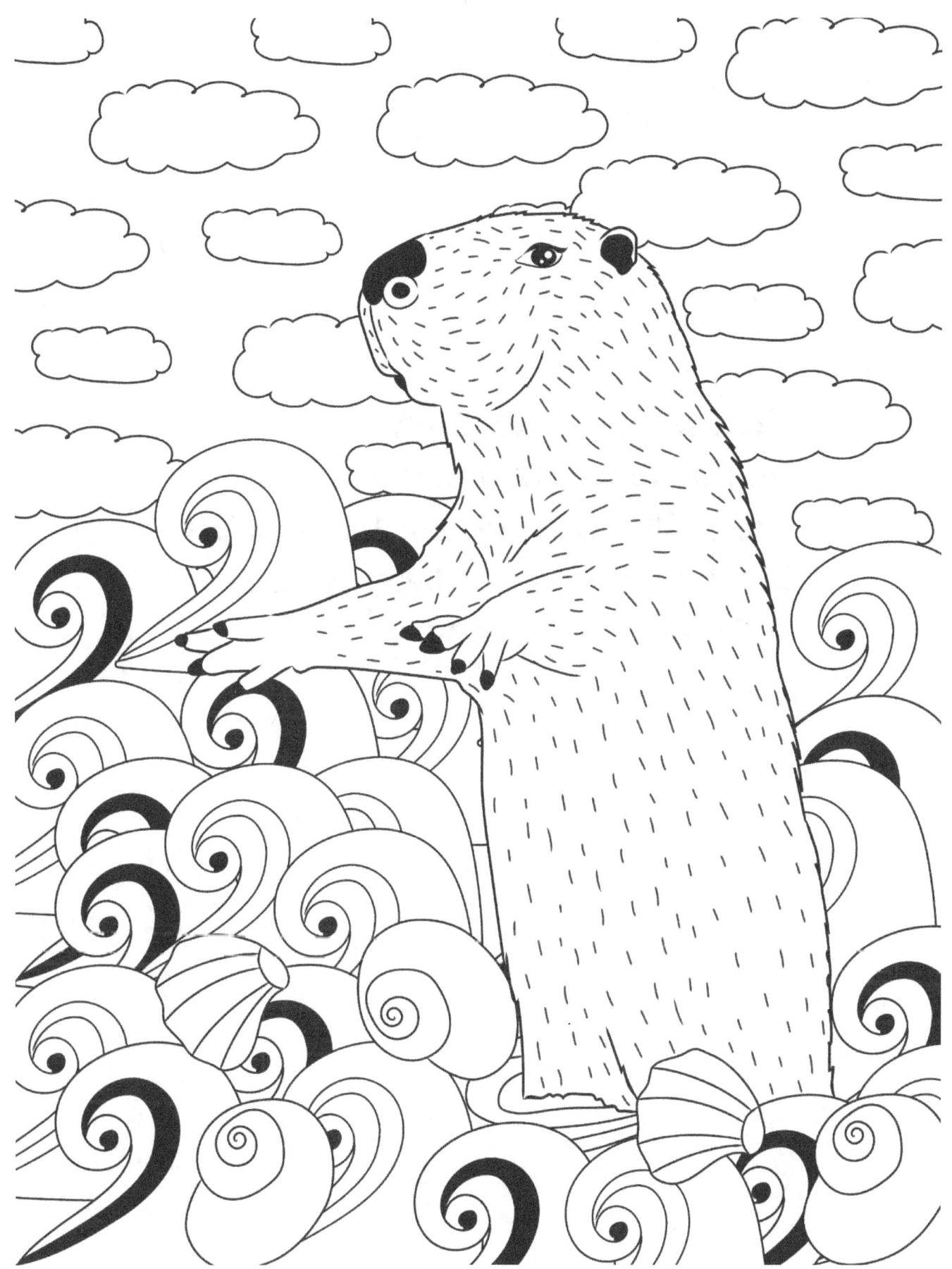

The front teeth of capybaras continually grow throughout their lives. This is important because the tough grasses wear down the size and strength of the teeth.

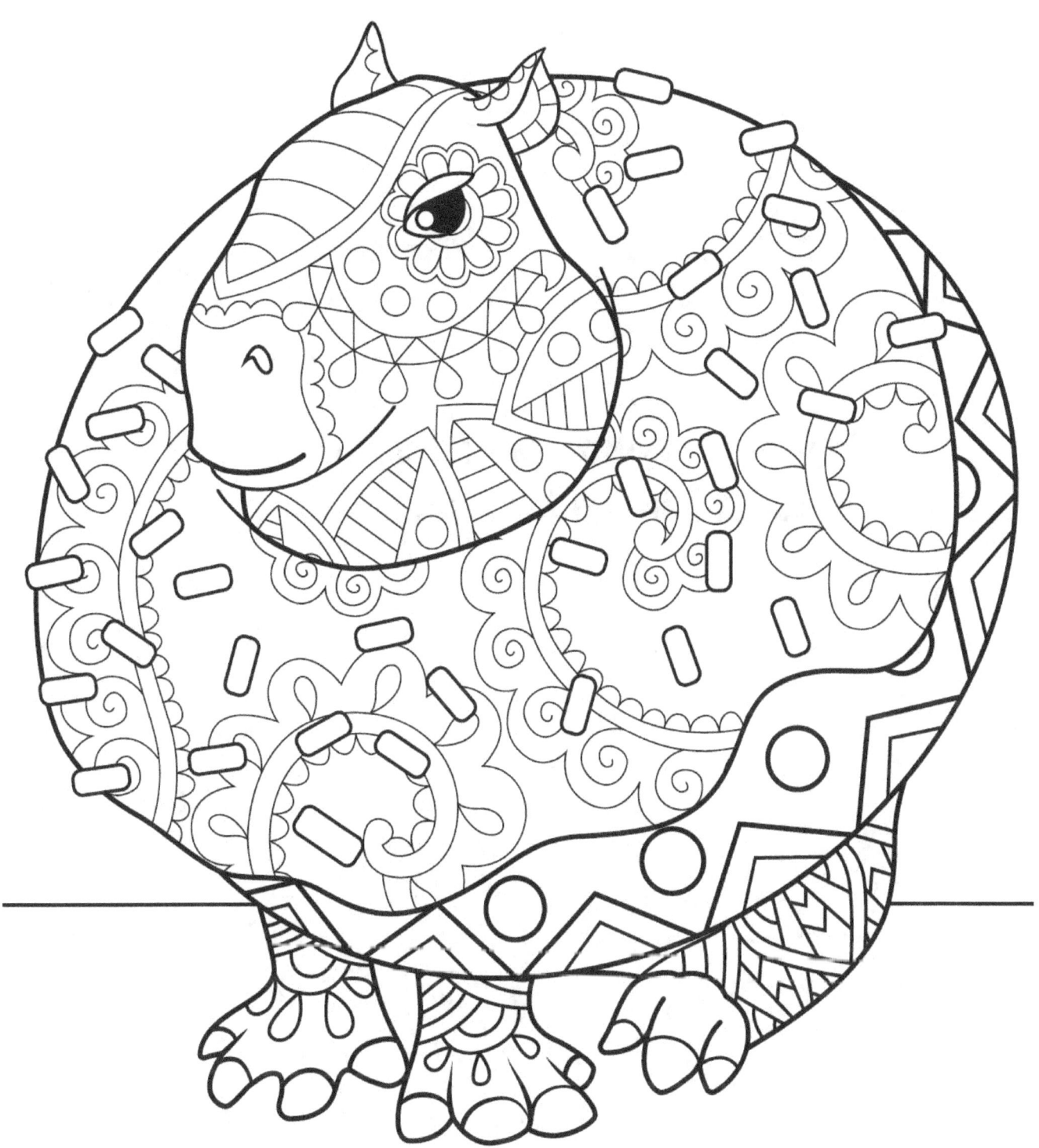

Capybara groups can sometimes have up to 100 individual rodents!

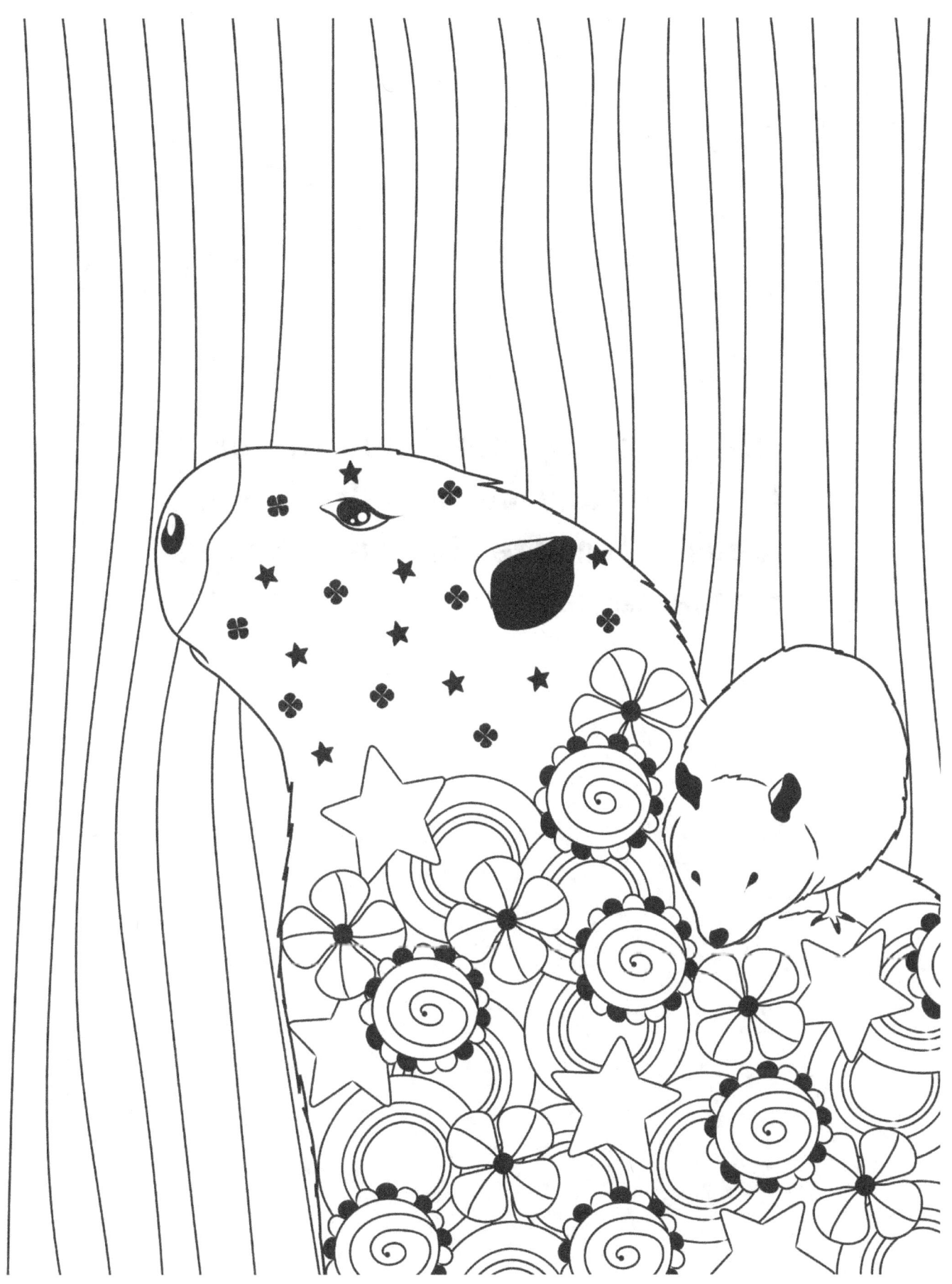

The name "capybara" comes from the Tupi language from Brazil and roughly translates to "one who eats slender leaves."

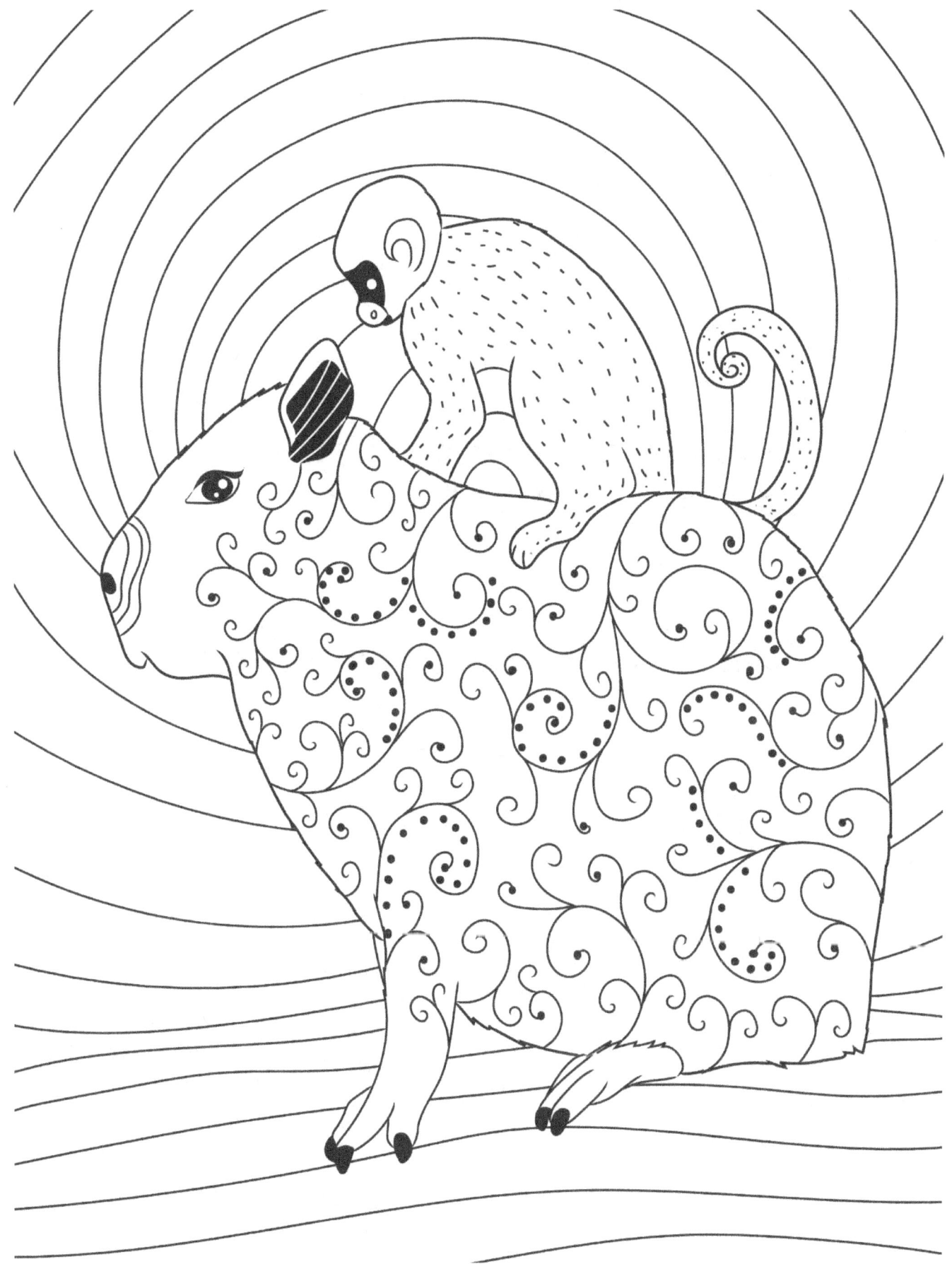

Groups of capybaras usually have 1 male for every 4-14 females.

Good luck…bad luck…who knows?!

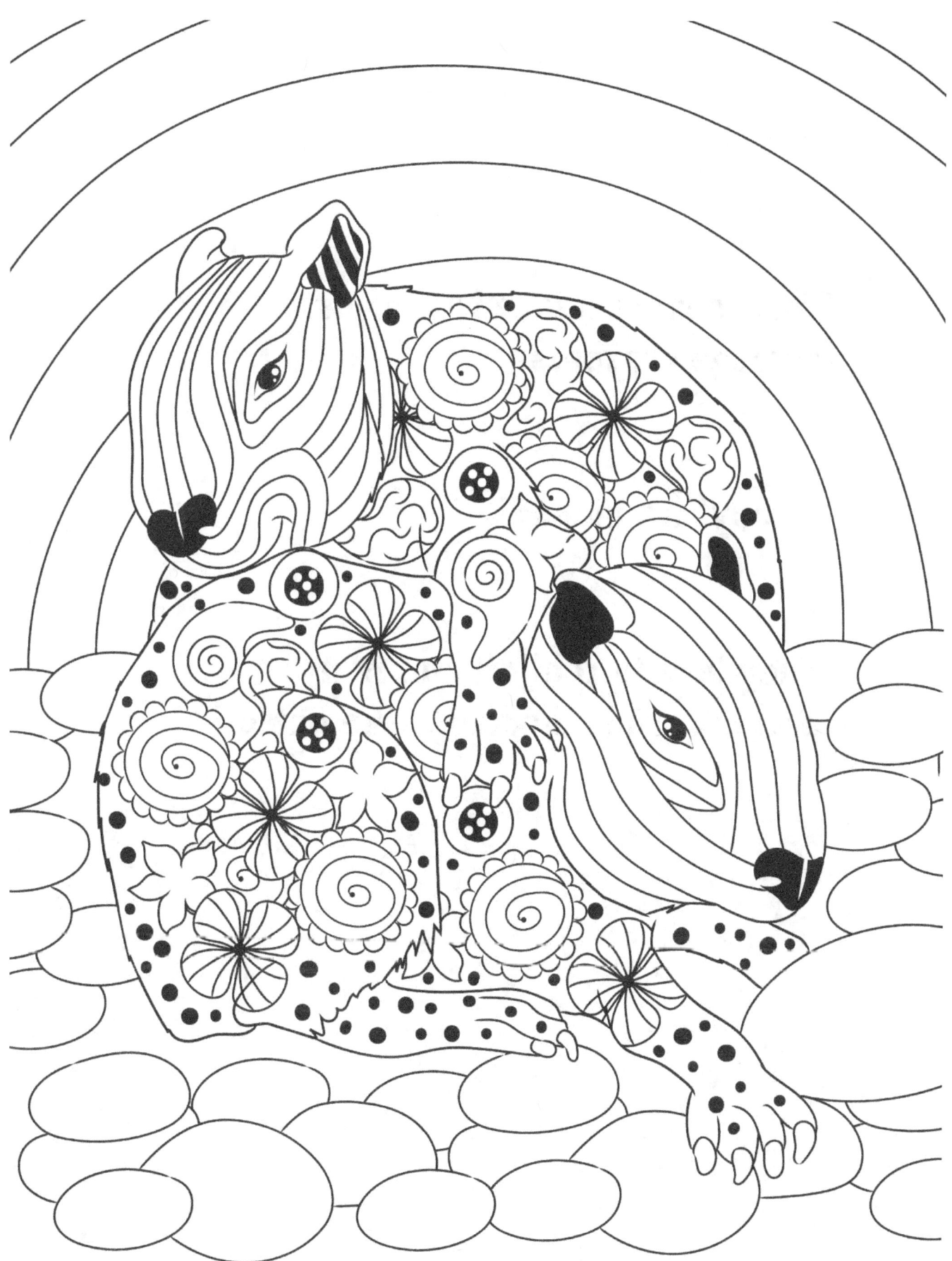

What's more relaxed than your average capybara?

A capybara in mud!

They love to cool off and flop around. The muddier….the better!

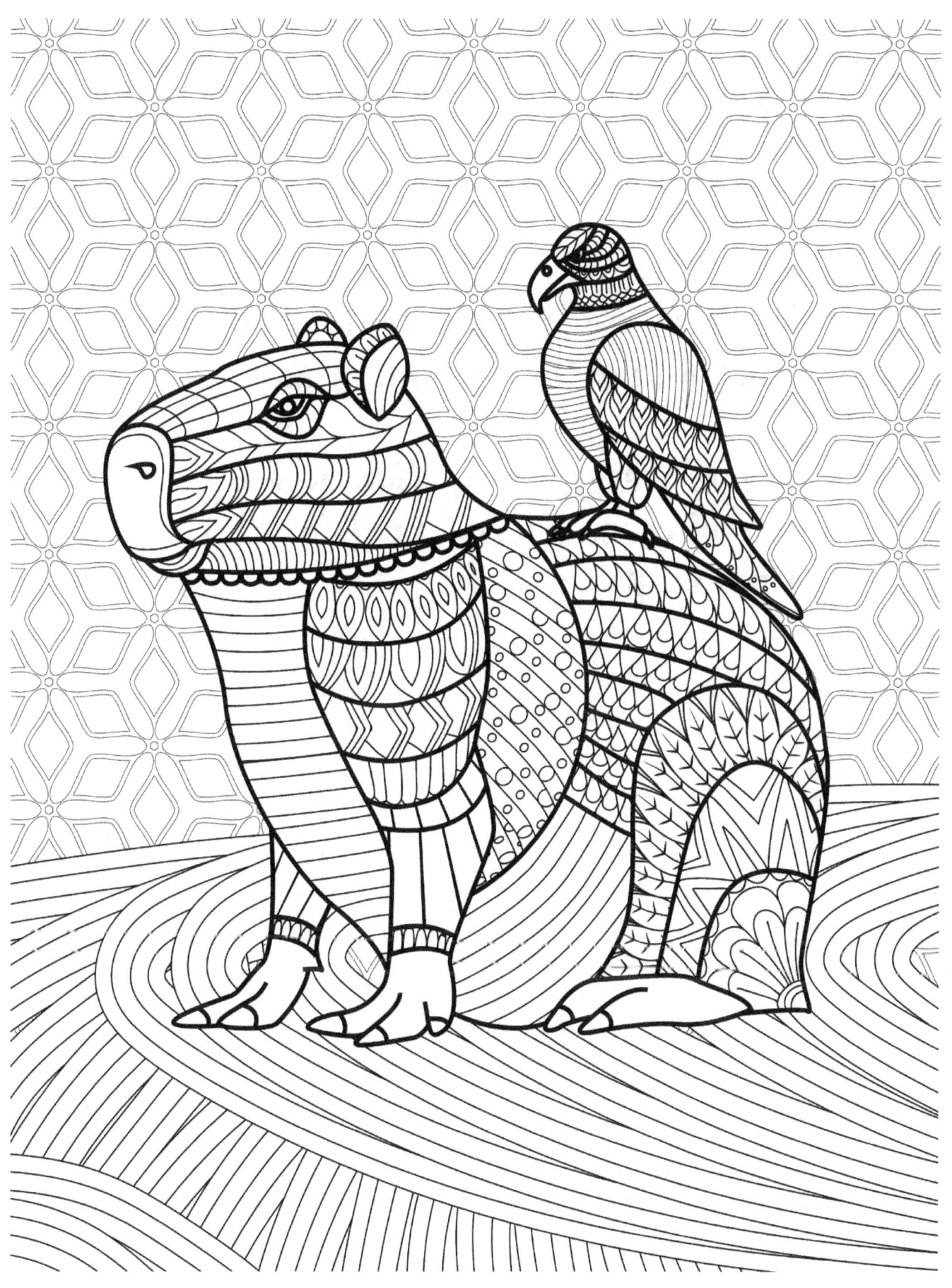

Capybaras are exclusive herbivores, which means they eat only plants.

Cats, however, are a different story in a different coloring book for a different day…

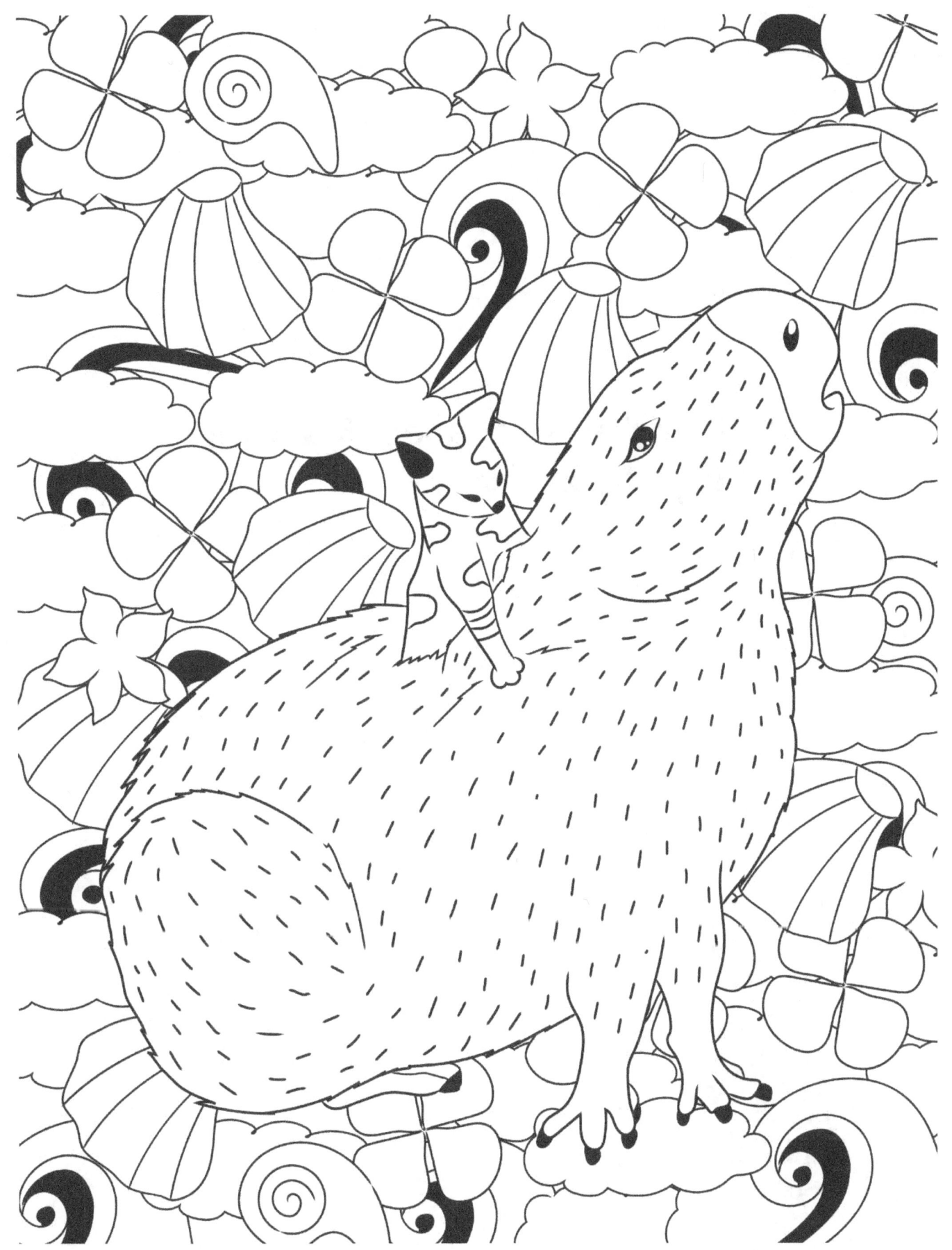

Adult capybaras eat about 8 pounds (~4 kg) of grass daily.

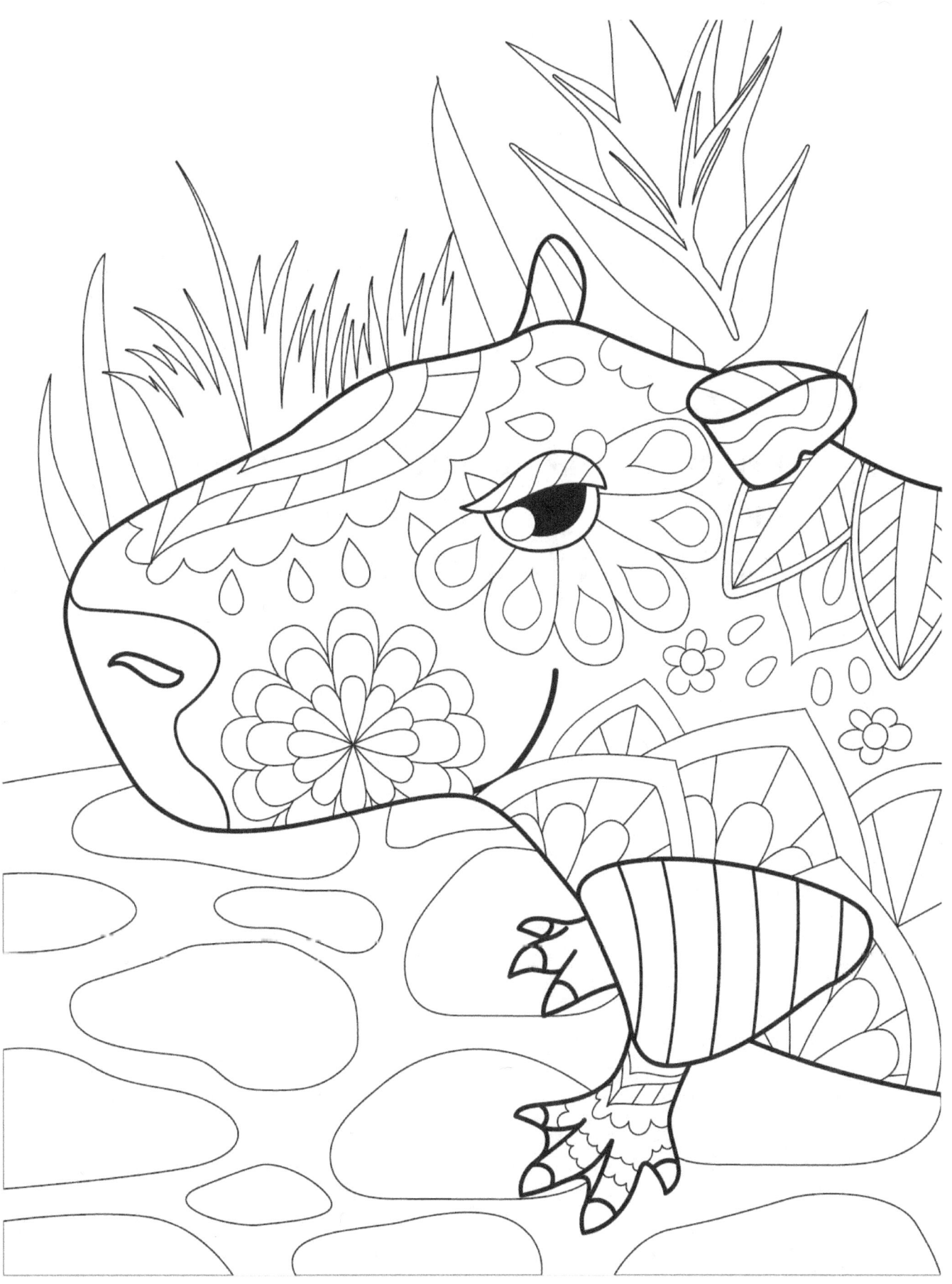

Capybaras can be quite vocal, making noises from whistling to purring, clicking, grunting, and barking.

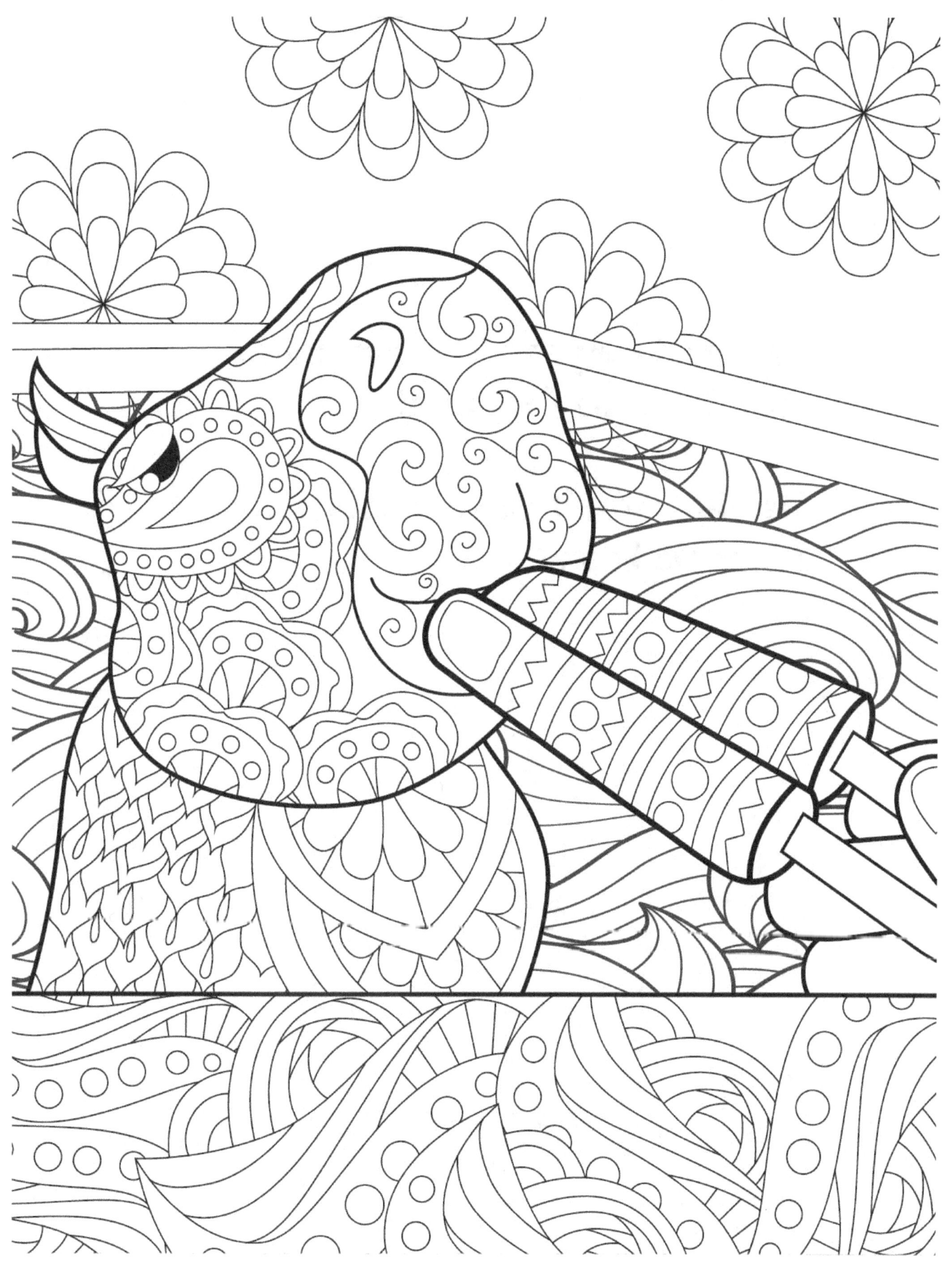

This next capybara is a superhero called Captain Capybara!

He/she doesn't exist in nature…as far as we know…

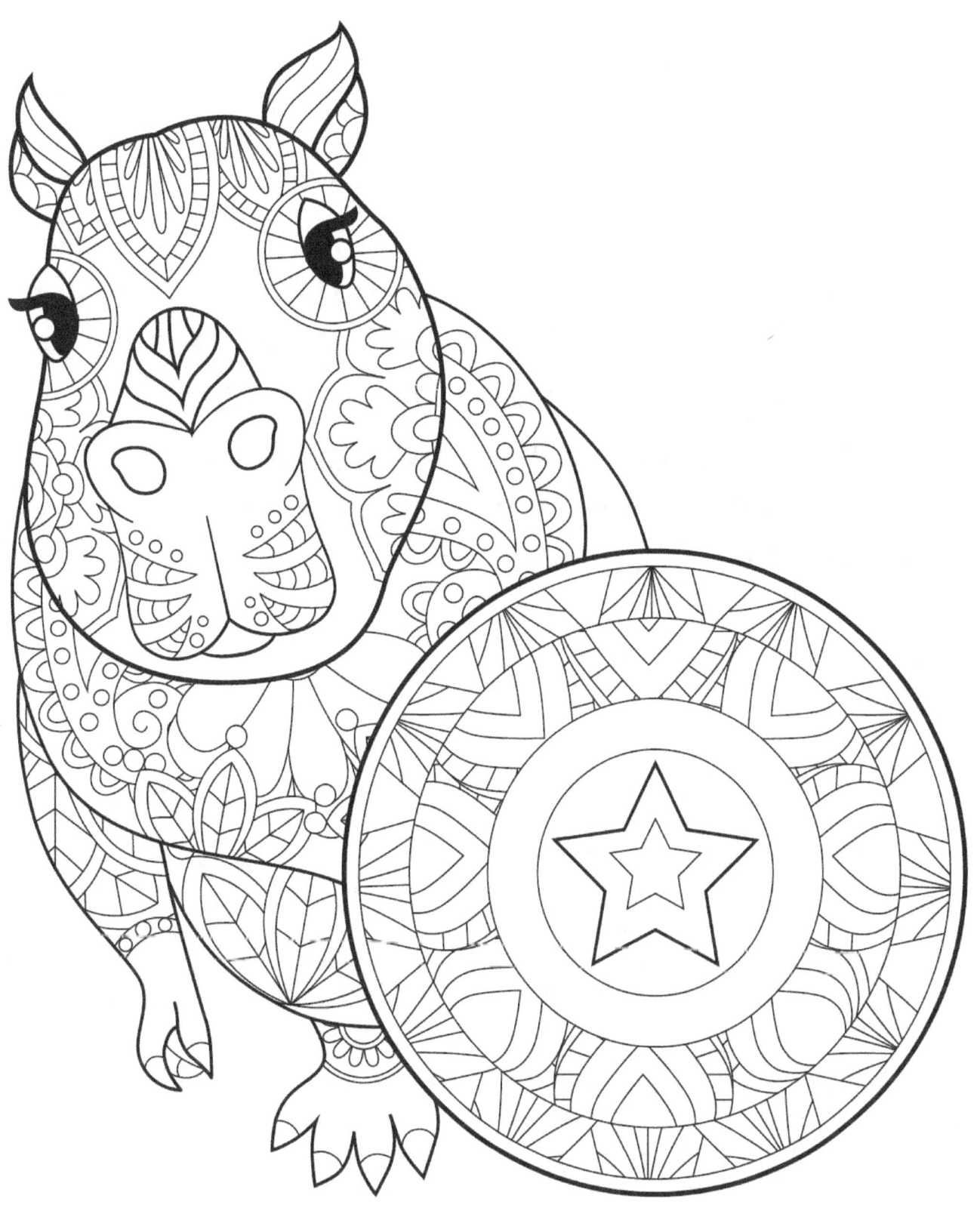

Capybaras will mark their favorite spots (and even other capybaras!) by rubbing their butts on them and by urinating on them. Special glands in the snout called morillos are also used for scent-marking.

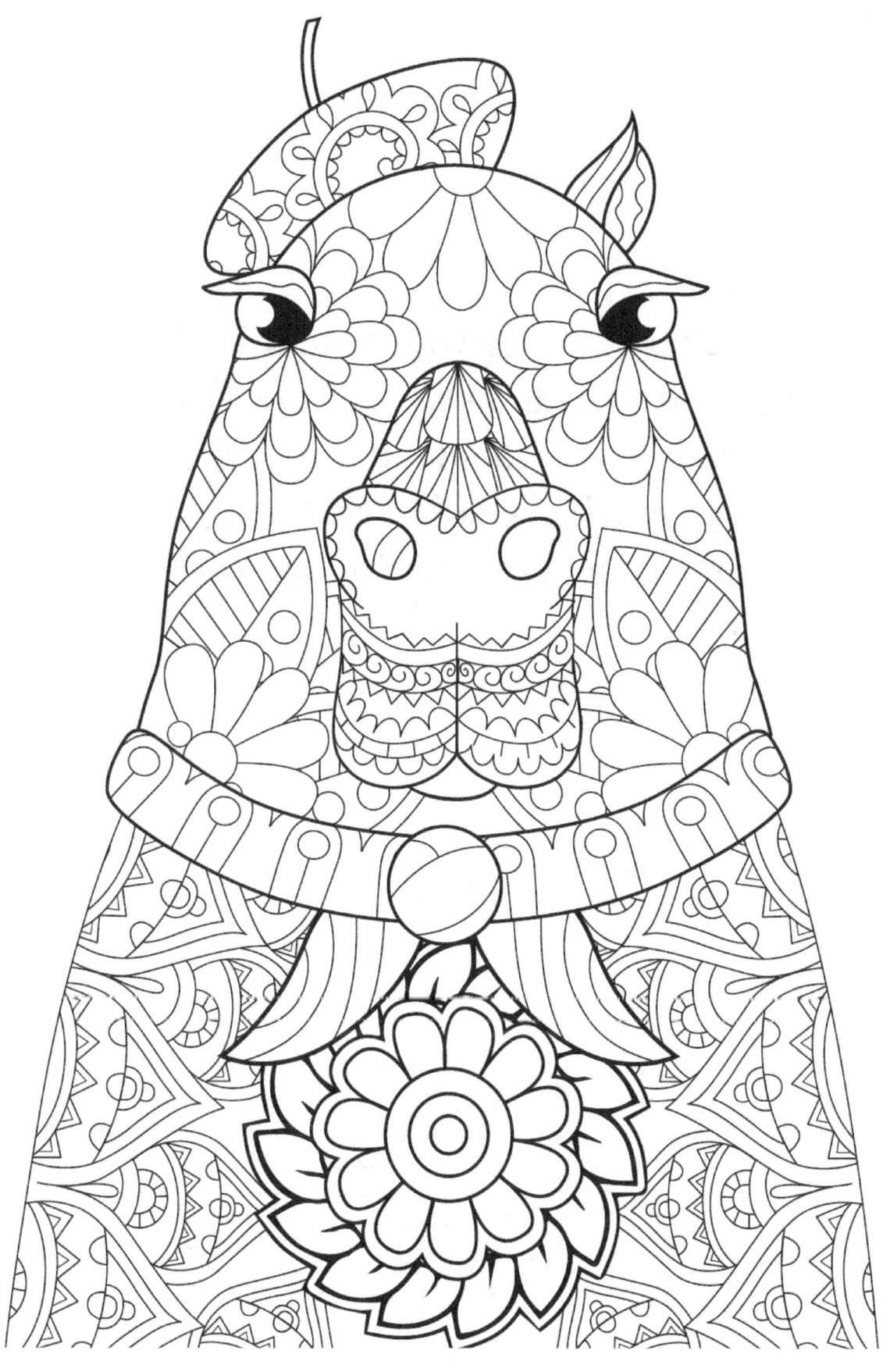

In Venezuela, capybara meat is popular during Lent and Holy Week. Some suspect this is because the early Church classified the giant rodent as a fish, and the practice stuck!

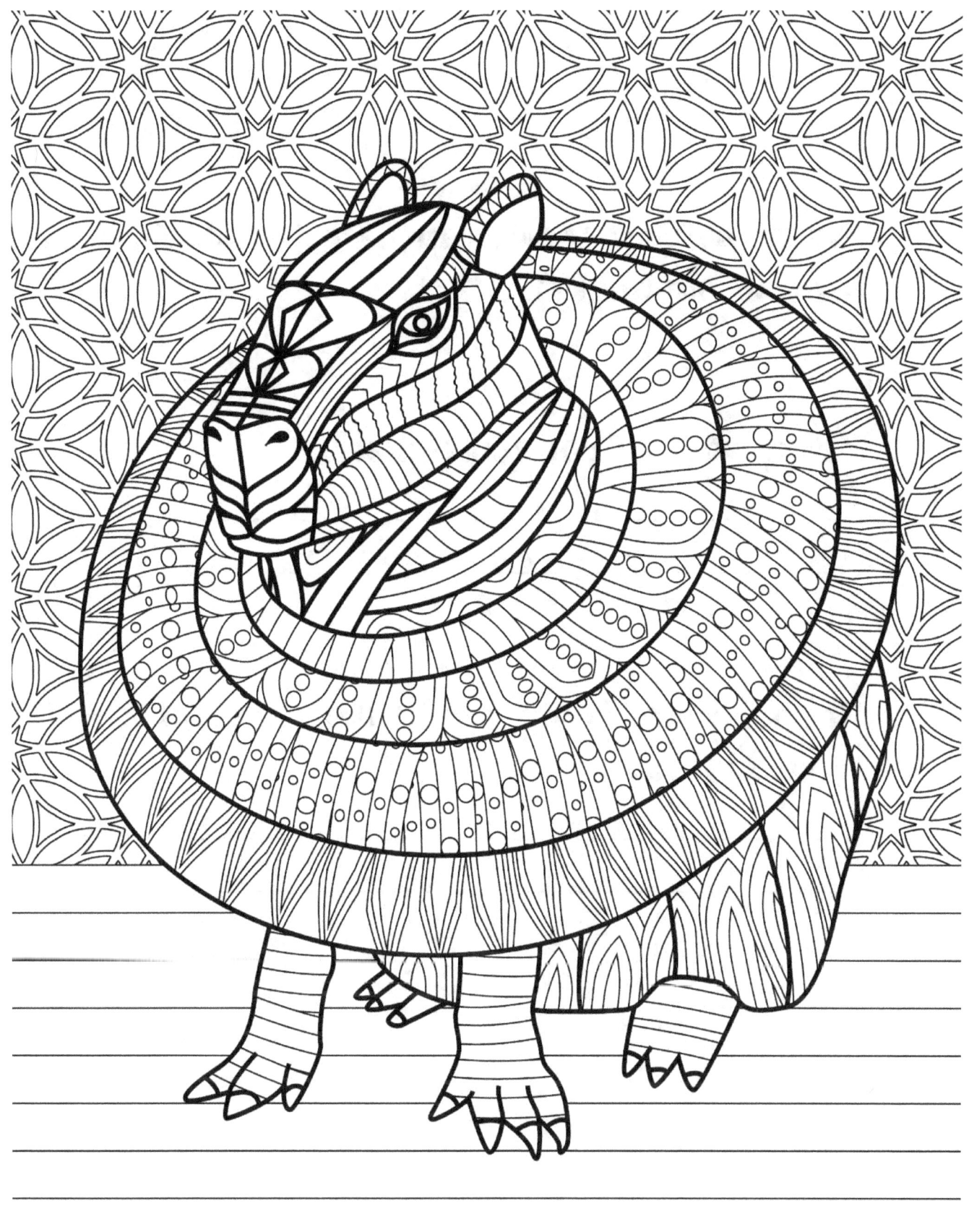

Have you ever seen a capybara (outside of coloring books)?

If so, what do you remember?

If not, where might you be able to meet your first capy?

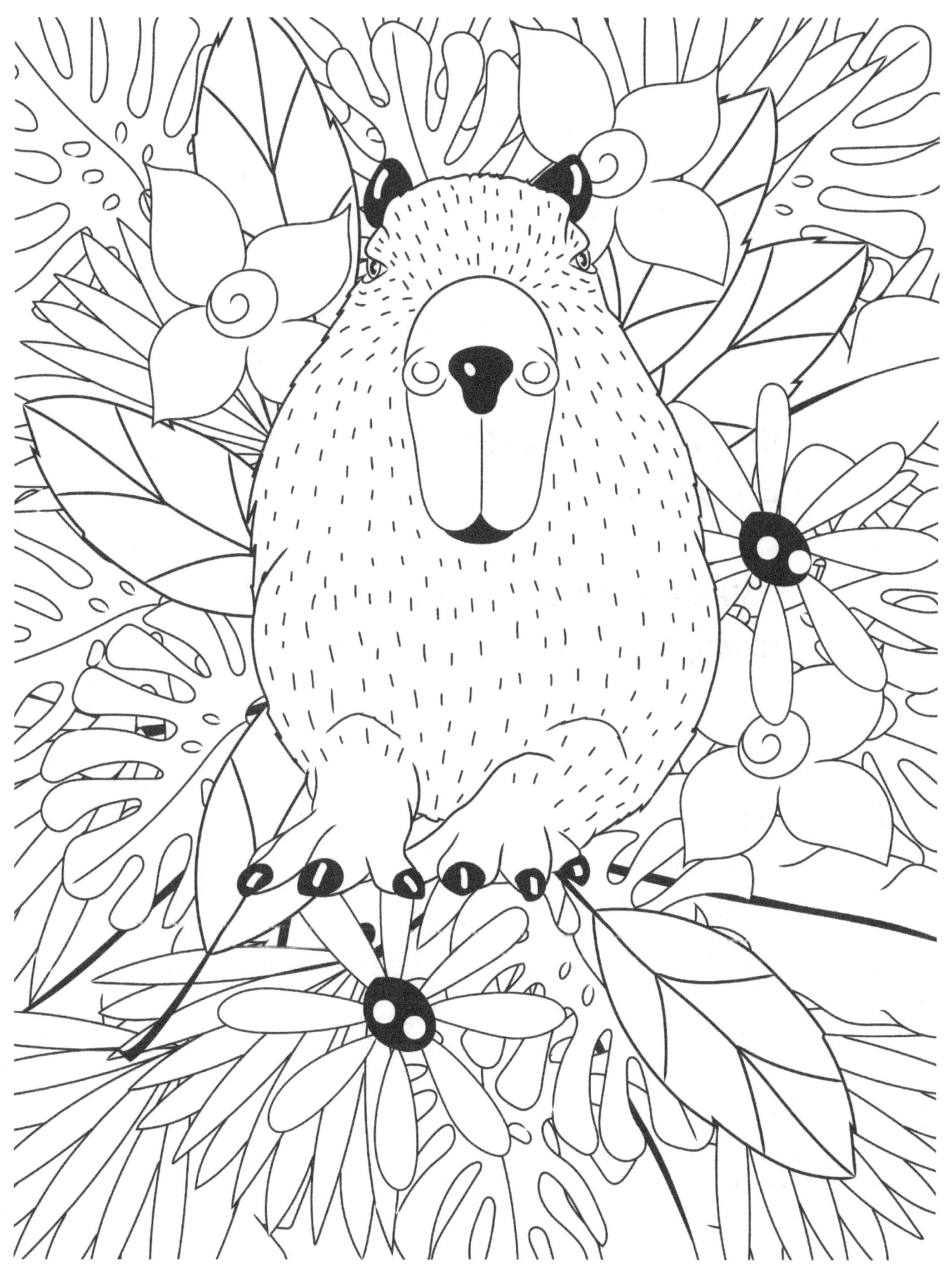

Uruguay has a capybara on their 2-cent coin.

Talk about money well-spent! At least, that's our two cents.

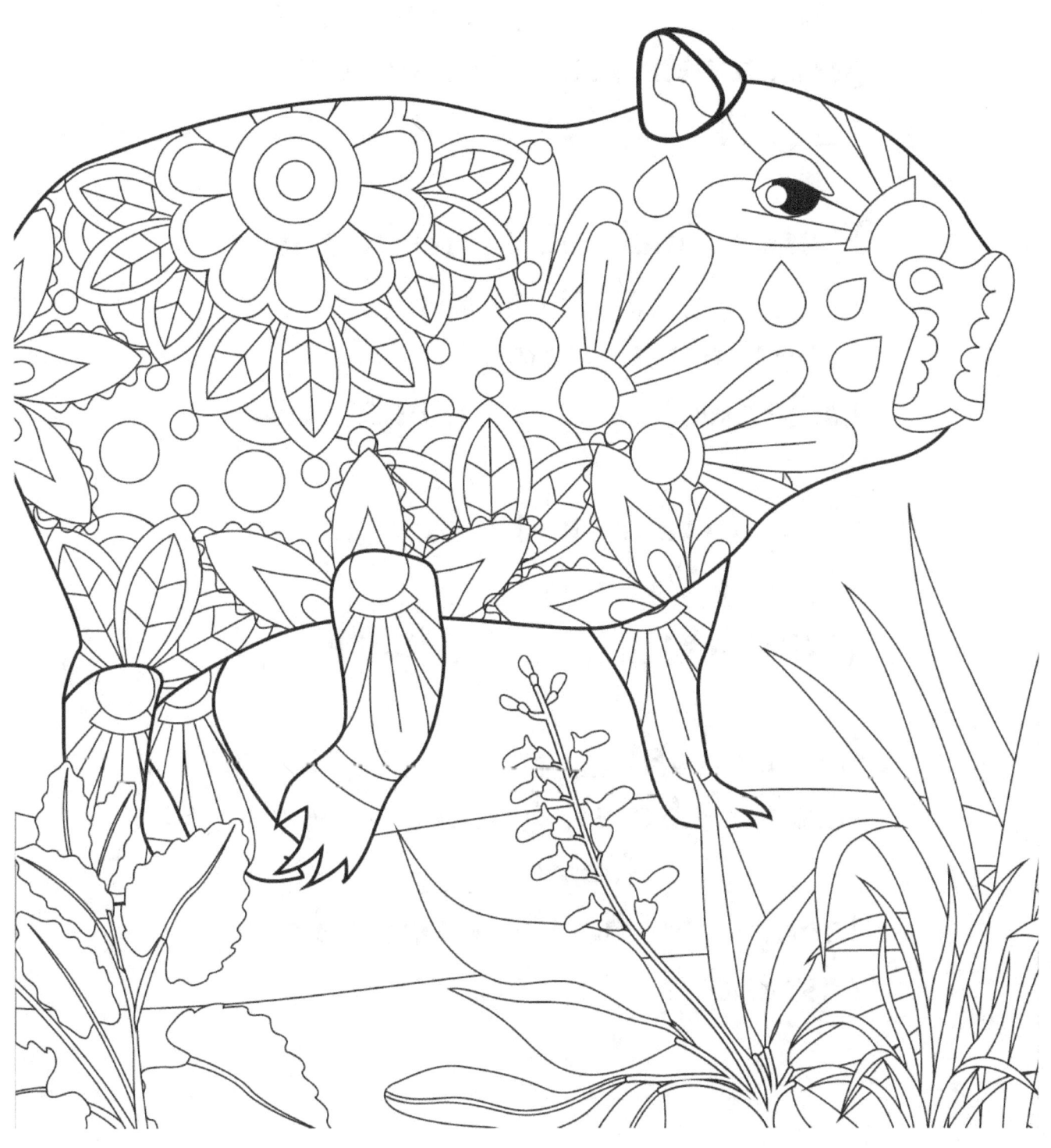

Time for a CAP - LIB!

The _____ (animal) is a giant rodent found in most of _____ (place).

These animals really like to eat _____ (plural noun), _____ (plural noun), and _____ (adjective) _____ (plural noun).

Wow, do they smell! In fact, some say they smell like _____ (adjective) _____ (noun).

If I had a pet _____ (animal, same as above), I would name it _____ (color) _____ (noun), and he/she would be my best friend.

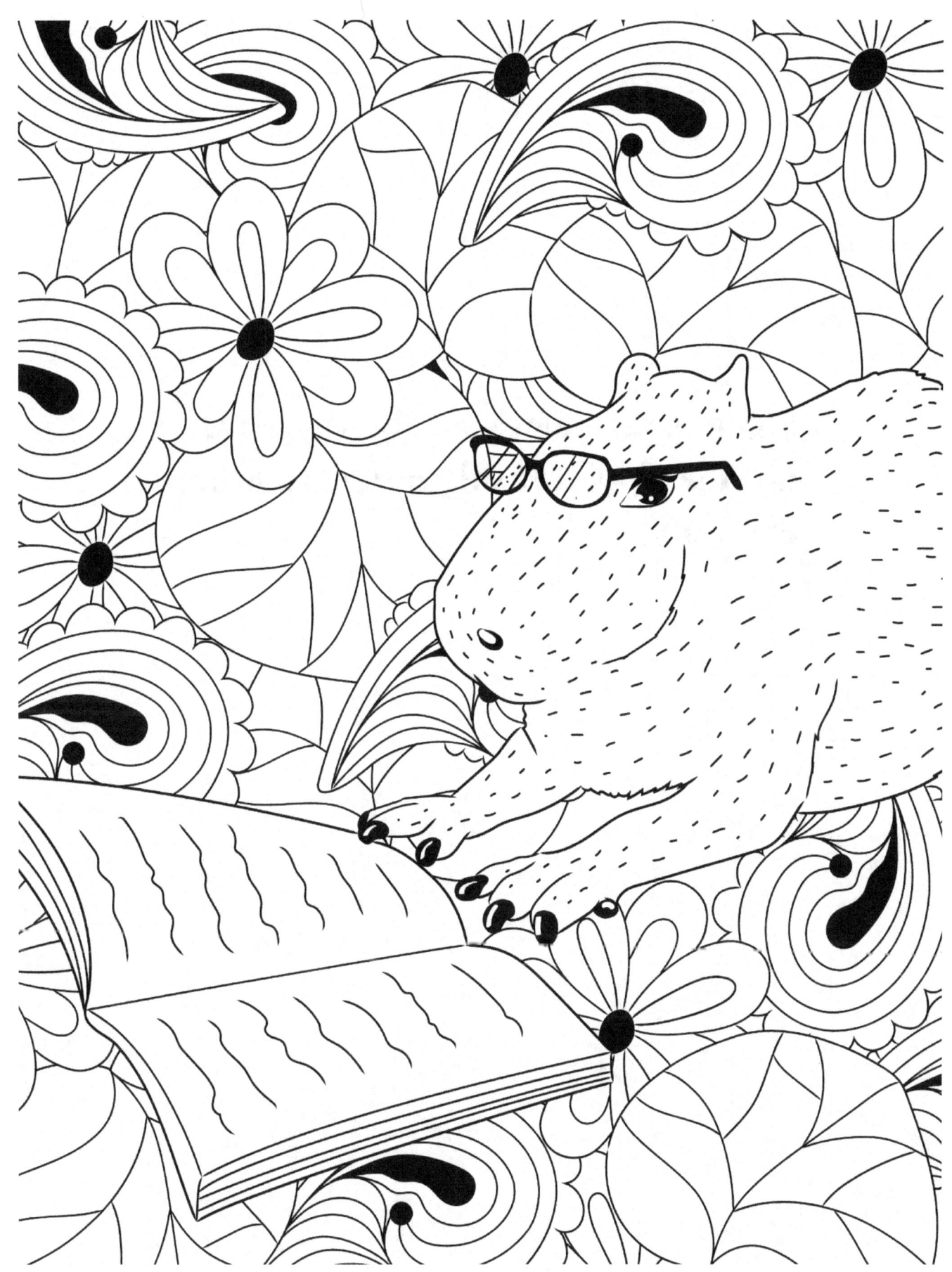

Some other names for the capybara include chigüire, chigüiro, carpincho, and Bob.

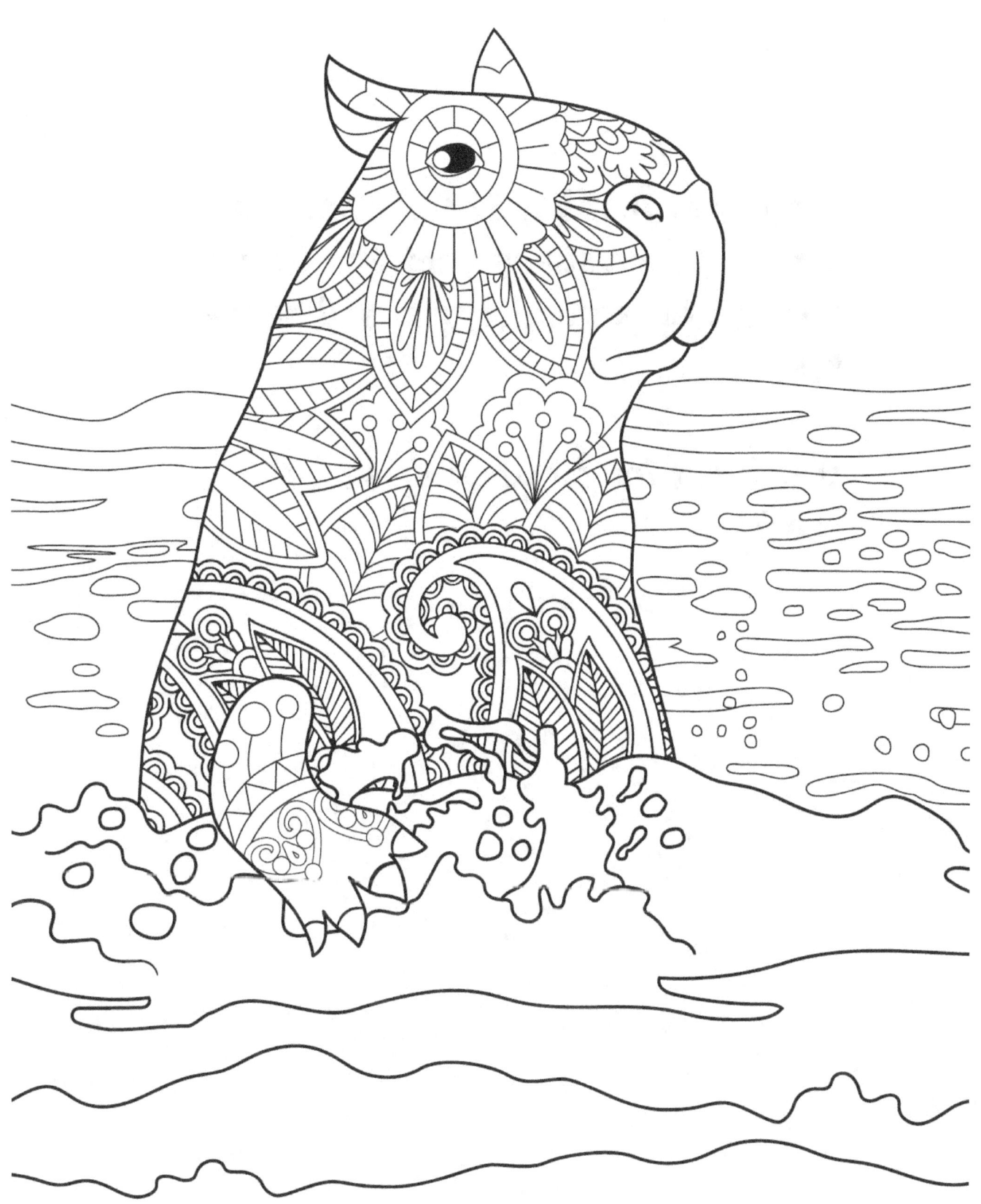

Capybaras that have been raised in captivity are usually gentle and allow humans to (carefully) pet and hand-feed them.

Watch out for those razor-sharp teeth!

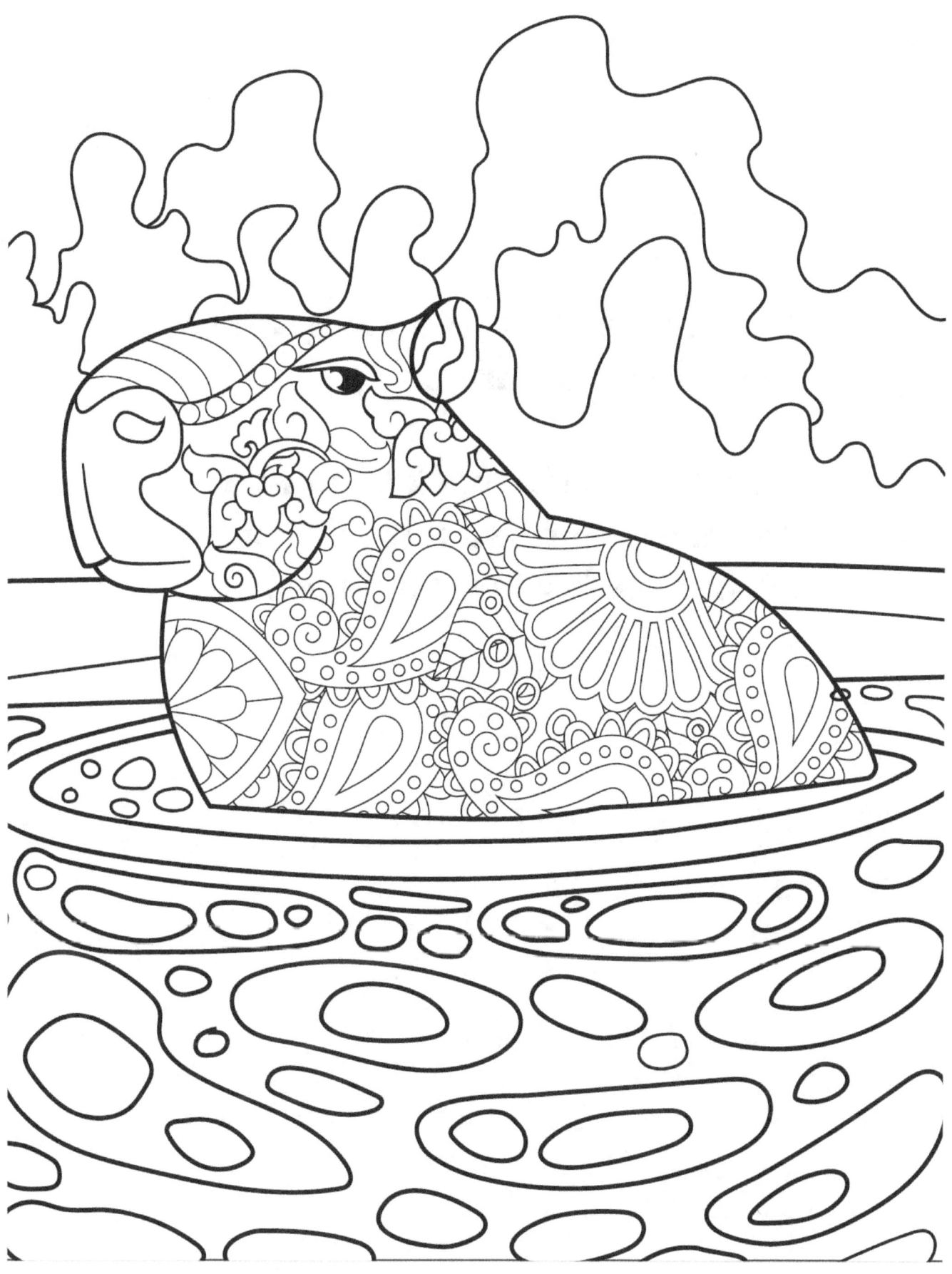

Having a capybara as a pet is against the law in some areas.

Having a coloring book filled with adorable capybaras probably isn't against the law in most places.

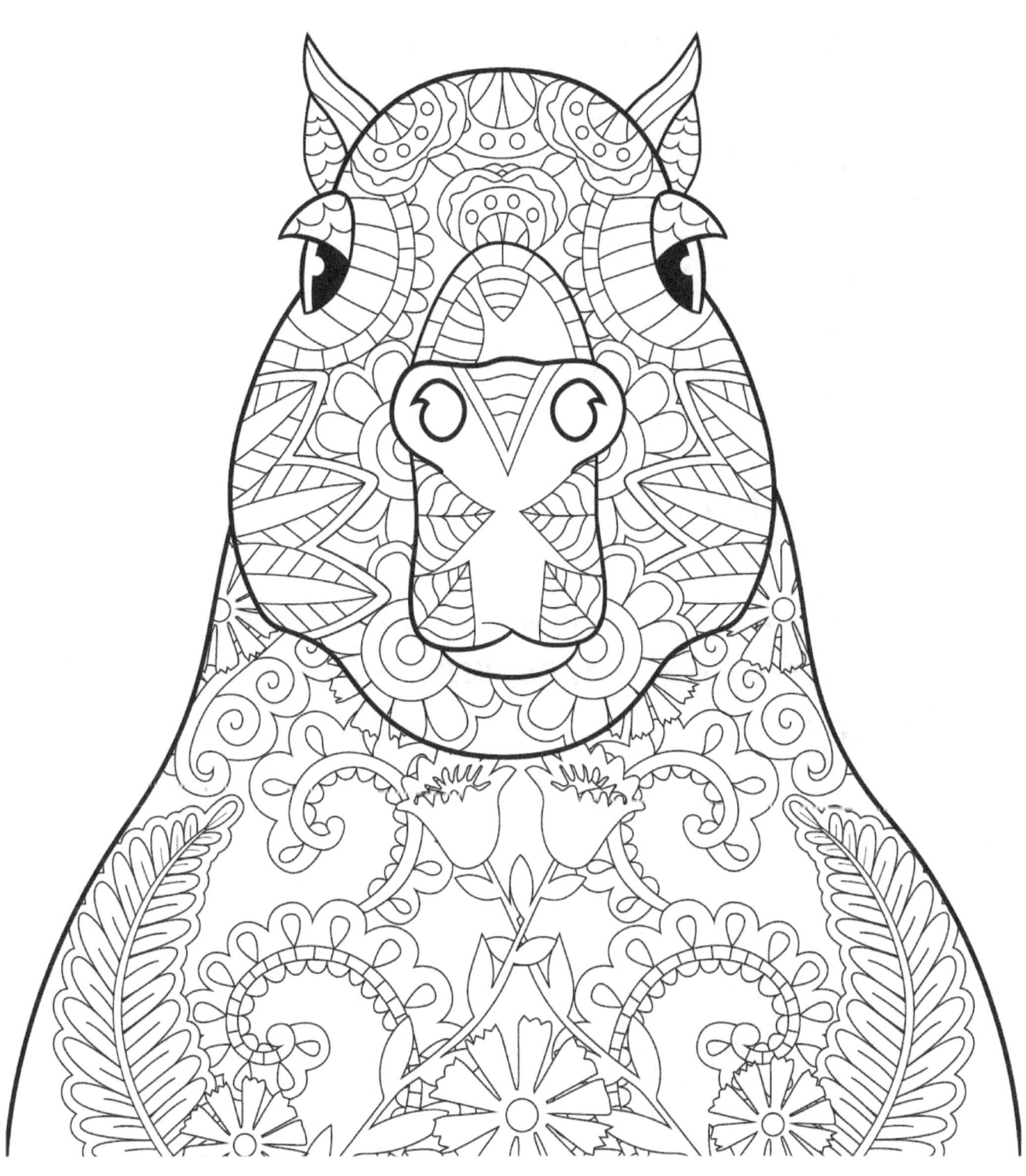

Want to draw a capybara?

Here's the easiest way:

1) Draw a potato*

2) Add legs

3) Add a smile!

*If you don't know how to draw a potato, a delicious burrito works, too.

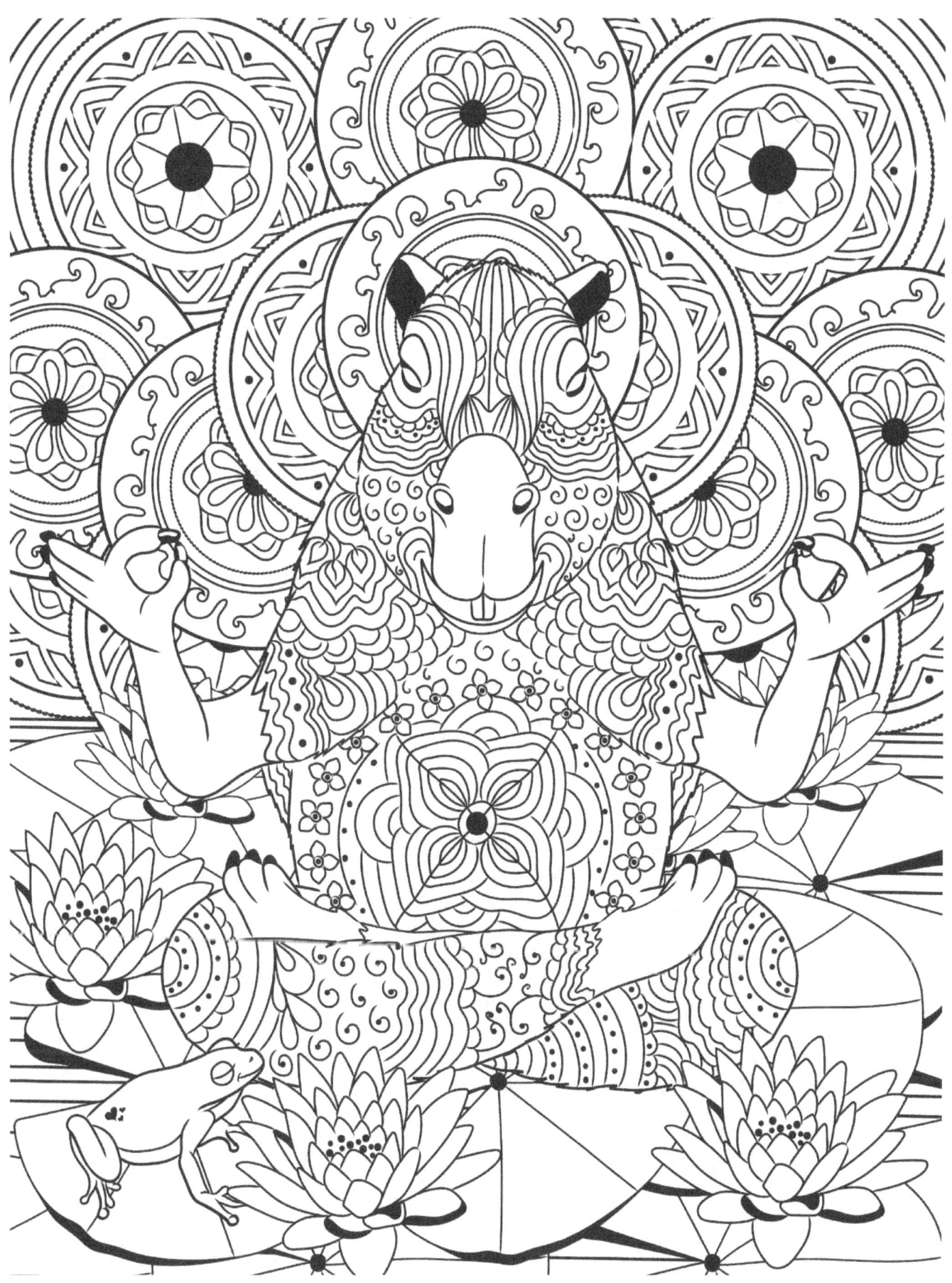

About the Editor

Jonathan Terry, DO, ABIHM, IFMCP is a board-certified osteopathic physician and surgeon, a general psychiatrist, a Diplomate of the American Board of Psychiatry and Neurology (ABPN), a Diplomate of the National Board of Physicians and Surgeons (NBPAS), and a Diplomate of the American Board of Integrative Holistic Medicine (ABIHM). He serves on faculty in several accredited medical schools, residency programs, and professional training programs. Dr. Terry is proud to be a National Health Service Corps Ambassador and works primarily with underserved populations, high-acuity inpatient psychiatric patients, and in consultation for program and policy-building initiatives. Dr. Terry's clinical interests include primary care consultation, nutrition, osteopathy, integrative medicine, kindness, and prevention.

Read more at www.DrJonathanTerry.com, and follow us on Facebook @MyCapybara and @DrJonathanTerry.

About the Book

The Pursuit of Capyness: A Zen Capybara Coloring Book is about community investment and involvement at every level. International artists from underserved areas were independently interviewed and contracted as contributors to enthusiastically craft this unique, award-winning collection while providing investment in their local communities. Proceeds from the book are reinvested in local mental health initiatives including prevention, education, and providing free or discounted care to those without insurance, those who cannot access care, students, and impaired professionals.

Check Out Our Other Colorful Titles

Eat The Rainbow &
The Eat the Rainbow Coloring Book

www.ingramcontent.com/pod-product-compliance
Lightning Source LLC
Chambersburg PA
CBHW081444220526
45466CB00008B/2507